CHIHULY
SEAFORMS

Effortlessly I glide through a sapphire sea, admiring sparkles on the underside of slick, moving wavelets rimmed with light, gently cupping an ephemeral bit of living jelly in my hand, then turning to glimpse a dazzling sight: corals, sponges, anemones, in a riot of soft pinks, blazing reds, luminous oranges, all marked with the disciplined wildness that I love in nature — and in the *Seaforms*. I want to touch my tongue to the ice-clear blue smoothness of one, *taste* the color, allow the texture to merge with the skin of my fingertips, *feel* the links between humankind and that realm where most of life on earth is concentrated — the sea. With great care, I tilt one shimmering creature toward the light and am rewarded with brilliant flashes of iridescence. I am not underwater; rather, I am looking at remarkable photographs of Chihuly's glass, remembering encounters with deep sea creatures who, if they could meet their glass counterparts, would sigh with envy or move in close to get better acquainted.

Others have eloquently described Chihuly's artistic predecessors and colleagues, his highly respected place among them and his growing legacy of students, collaborators and admirers. Here, I would like to describe something that goes beyond the realm of art — how the *Seaforms* and the beauty and spirit reflected in each glowing rendition inspire those who see them to value and care for the living sea. Whatever else these wondrous glass objects are as reflections of skill, passion, teamwork and sheer genius, they are also tributes — a celebration of the sea that the child Chihuly first knew near Seattle, the wild ocean where he later sailed as a fisherman, the New England shore where he developed as an artist at the Rhode Island School of Design, the oceans and archipelagos that he has sought worldwide, and, in due course, the Northwest Coast near the phenomenon known as The Boathouse, where he and

the creative team who works with him how create miracles with glass.

When I first met Dale Chihuly, what caught my eye was not his curly hair, his cherubic, smiling face, the halo of blue-fire energy that surrounds him like a flame, or even the crowd of people listening to his every word. Rather, it was the drizzled mix of colors arching over the rounded toes, sides, heels and laces of the *shoes* peering out from the impeccably-creased trousers of his tuxedo that provoked my inner voice to whisper, "Pay attention. This is someone special."

I have yet to see a scientific tome introduced by an artist, but it is just like the consummate artist and beloved maverick Chihuly, the man with the rainbow shoes, to ask a scientist—a marine biologist—to introduce a volume illustrating his art. Perhaps he did so because I had described to him my personal love for the magical properties of glass — a passion that he shares, but for different reasons.

"My dream," I told Chihuly, "is to have a glass submarine, a clear sphere within which I can sit, warm and dry, and fly to the ocean's greatest depths, seven miles down." The idea is not as fanciful as it sounds. Of all the materials engineers could select to withstand the pressure in the deepest sea — 16,000 pounds per square inch— glass is perhaps most appealing. It is, after all, virtually incompressible. With increasing pressure, glass behaves as a liquid; the molecules move closer together and, in so doing, make the structure stronger. Engineers hoping for an easy way to create loud sounds underwater for acoustic research made the astonishing discovery that a hollow glass sphere is so resistant to breaking when deployed thousands of feet underwater that high-powered bullets fired at close range merely splay harmlessly on the sphere's smooth surface. Other strong durable materials can be used to build deep-diving submarines— titanium, steel, even certain synthetic composites— but no material other than glass or glass-like ceramic is also transparent, a vital consideration for those such as I who like to see where we're going underwater.

"And that's not all," I said to Chihuly, "I am inordinately fond of tektites

those smooth, rounded, hollow, glassy bits of space debris that are found most commonly in the sea." My attraction for this other way of looking at glass began for me when I was an aquanaut living for weeks at a time underwater in a partly clear hollow laboratory dwelling known as "Tektite." The name was chosen to signify the sea-space parallels involved with living underwater during a program partially sponsored by NASA.

Chihuly's fascination with glass may have started as a child, he says, when he discovered gem-colored bits of it while beach combing. But serious work in this versatile medium began in 1963, when he wove small pieces of used glass and copper wire into creative tapestries. Using suitably aquatic terms, Chihuly notes that gradually, "I learned more about the technical and fluid possibilities of the material and soon became immersed in my glasswork."

The real adventure began one night in 1965 when Chihuly snared a dollop of molten glass on the tip of a steel pipe and, with an experimental puff created a small but wondrous bubble that triggered a new direction for his talents. This was the first step towards the exquisitely-controlled mastery of fire, gravity, glass, air and centrifugal force joined to Chihuly's distinctive exuberance and spontaneity that is so apparent in his glass sculptures today. Three decades later, Chihuly conveys an undiminished sense of wonder when he says, "To this day, I have never gotten over the excitement of molten glass.... The process is so wonderfully simple, yet so mystifying... I'm still amazed to see the first breath of air enter the hot gather of glass at the end of a blowpipe." Part of Chihuly's genius, of course, is in making something supremely difficult and complex appear easy, as simple, say as a perfectly-formed nautilus arising from a nondescript mass of eggs

The sustained thrill may relate to the distinctiveness of each and every creation. While there is an underlying vision, dozens of split-second decisions determine the outcome. On a coral reef just as in a Chihuly series, no two crea-

tures are alike; nonetheless, there are recognizable themes that run through the entire system like organic melodies. The dynamics of a reef require close but ever-changing interactions among the players. The life and beauty of reef corals are utterly dependent on relationships such as the symbiosis between plants and animals, and the partnerships among small shrimp and large fish and between opalescent crabs and craggy sea cucumbers, all of which come together harmoniously to create much of the tangible music we admire and call "coral reef."

Just so, Chihuly makes much of the teamwork underlying his art. He speaks of the vibrant and vital symbiosis between himself and his colleagues and students. To these I would add the enduring partnership he has with nature — with the sea, with life around him and with hosts of people such as I who are forever grateful to the wondering, caring spirit of the Chihuly child that continues to live within the adored and undisputed grand master of glass.

Sylvia Earle is an author, explorer, oceanographer, conservationist and former Chief Scientist of the National Oceanic and Atmospheric Administration.

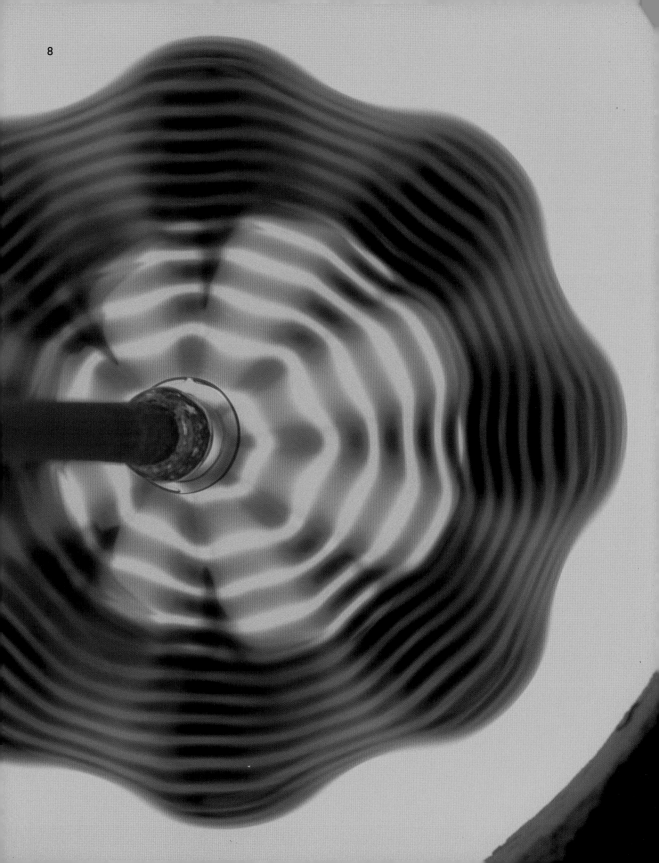

"My work, to this day,
revolves around a simple set of
circumstances: fire, molten glass,
human breath, spontaneity,
centrifugal force and gravity."

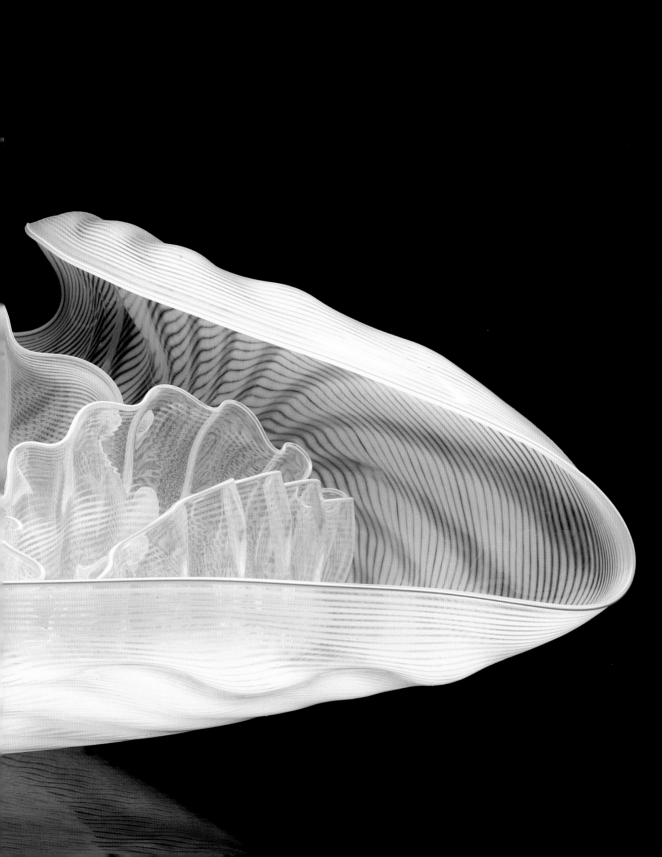

1984 White Seaform Set with White Lip Wraps, 5 x 18 x 12"

1981 Coral Pink and White Striped Seaform Single with Black Lip Wrap, 11 x 9 x 8"

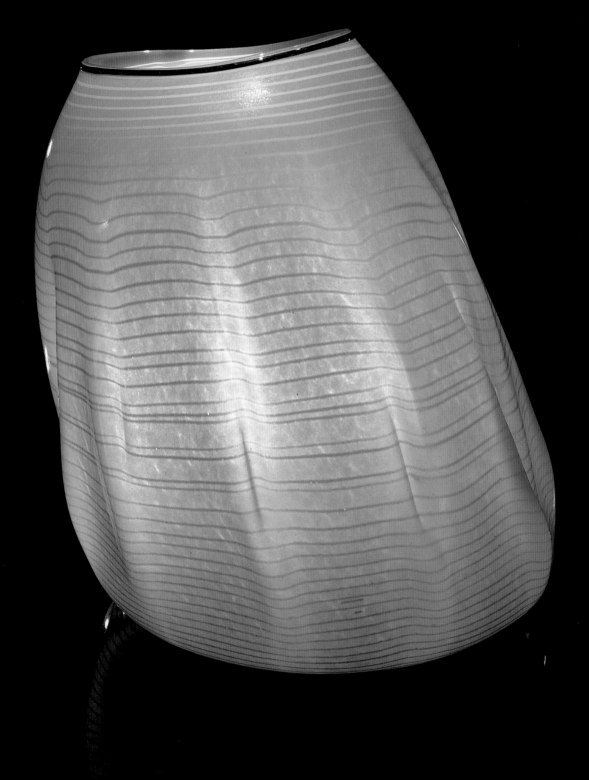

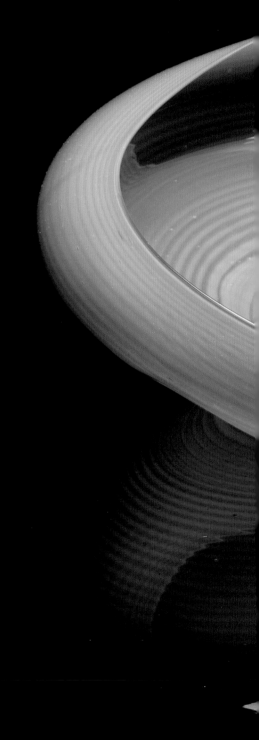

1980 Pale Green Seaform Set with Green Lip Wraps, 4 x 12 x 12"

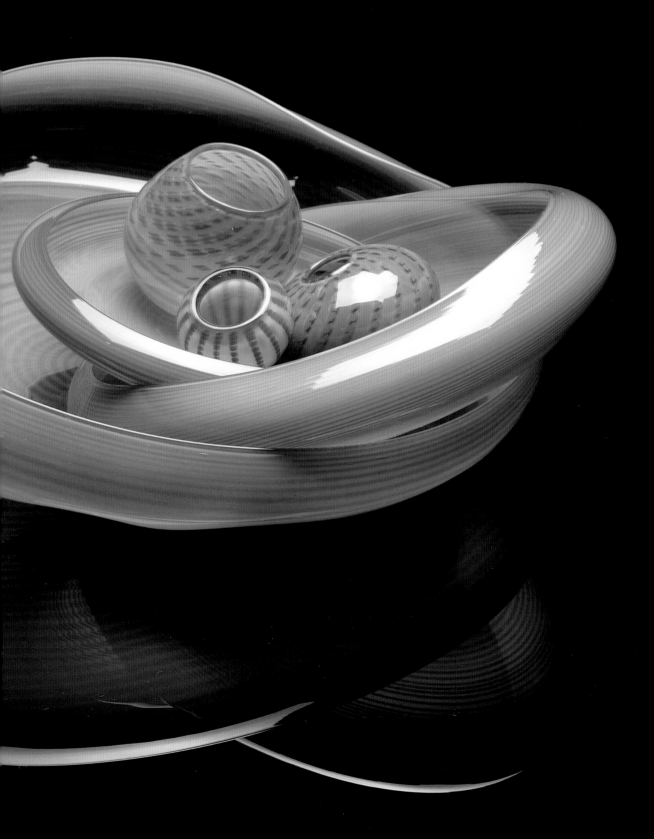

1980 Pink Seaform Set with White Stripes, 6 x 10 x 10"

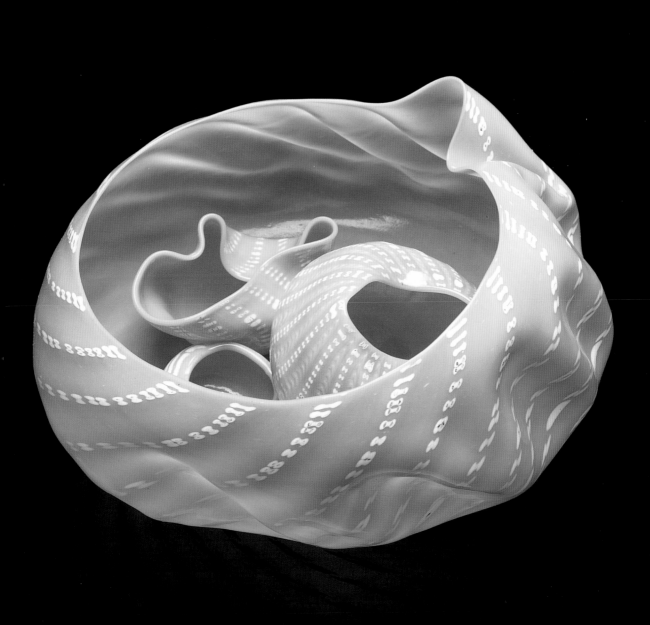

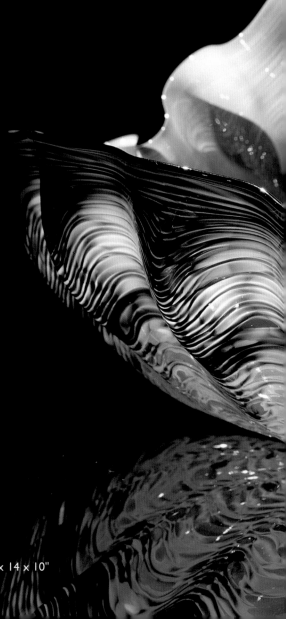

1982 Periwinkle Blue Seaform Single with Deep Blue Lip Wrap, 8 x 14 x 10"

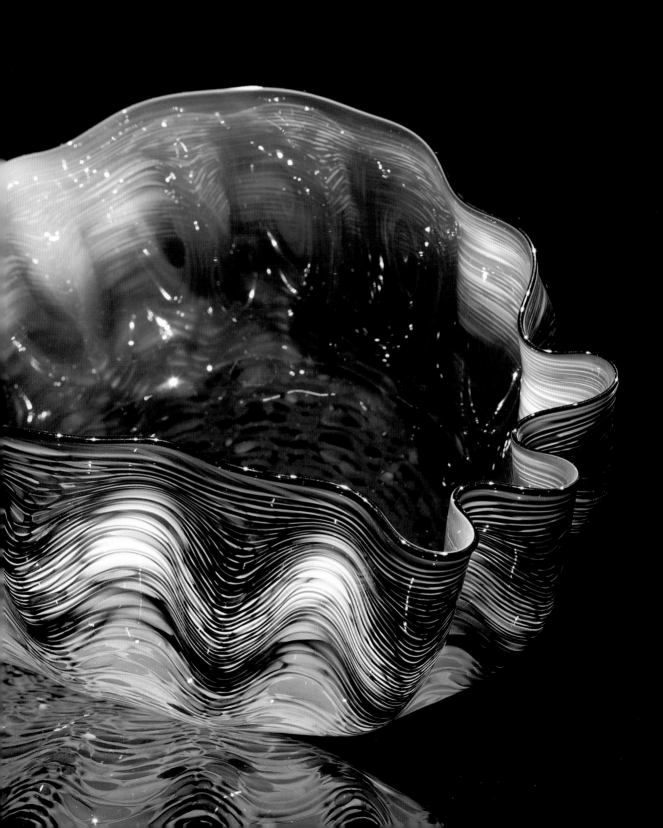

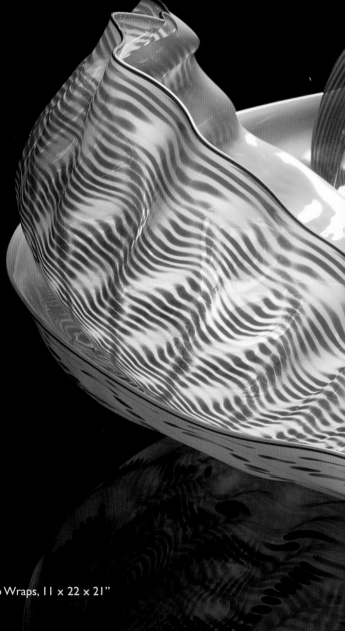

1982 Cadmium Red and Black Seaform with Black Lip Wraps, 11 x 22 x 21"

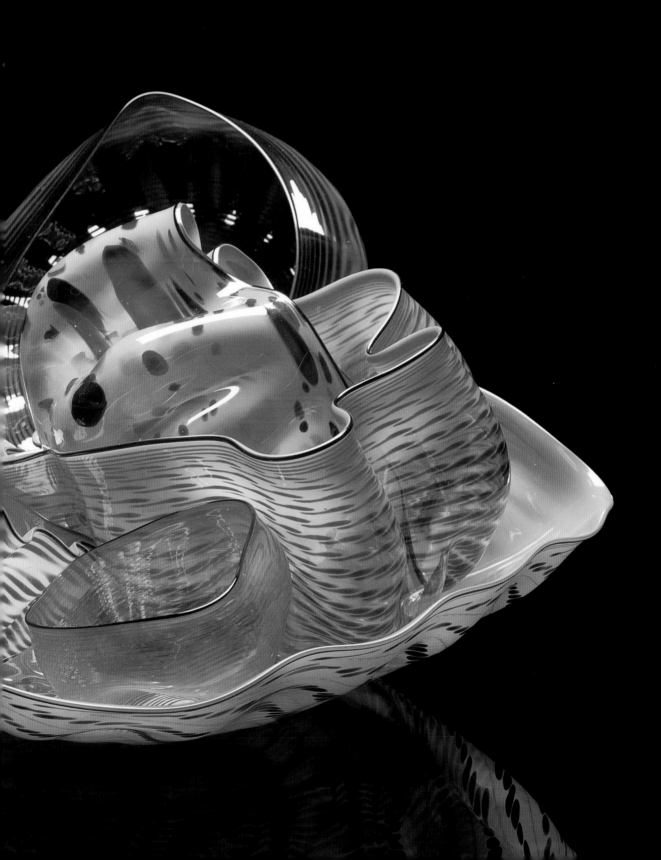

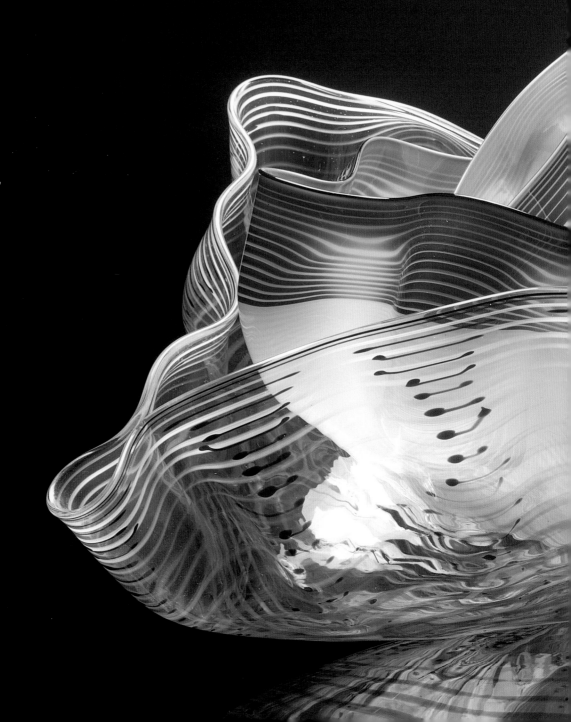

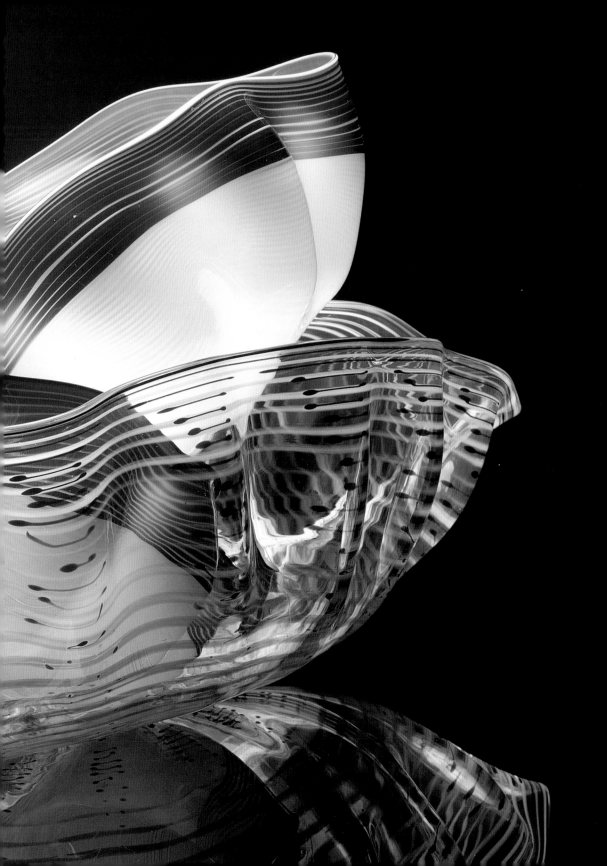

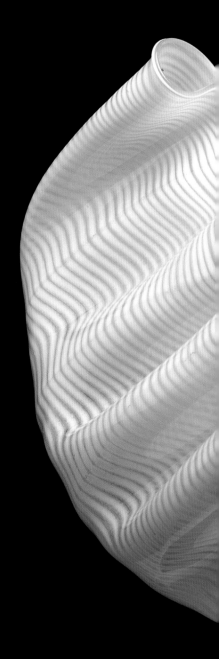

← 1983 White and Oxblood Seaform, 11 x 19 x 9"

1990 Pink and White Seaform Set, 9 x 16 x 8"

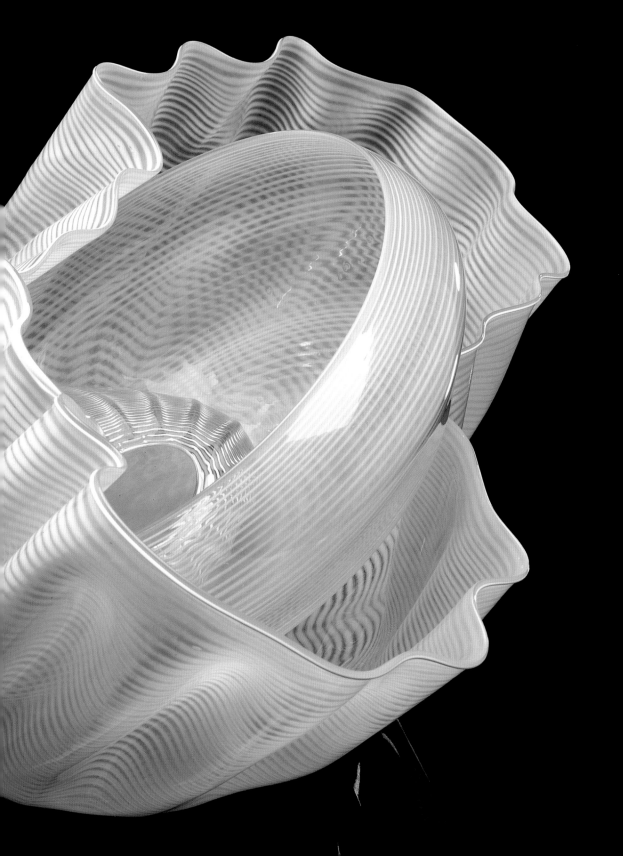

1981 Moss Green and Orange Striped Seaform with Orange Lip Wrap, 10 x 10 x 9"

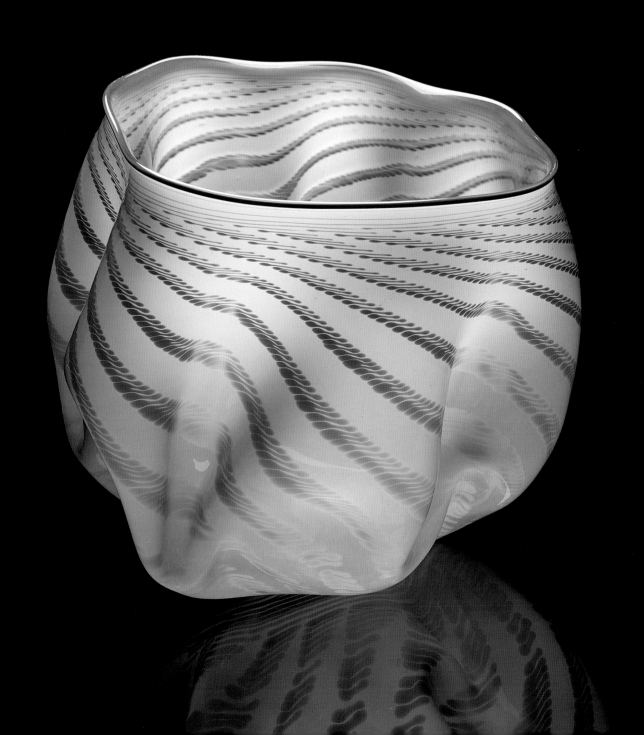

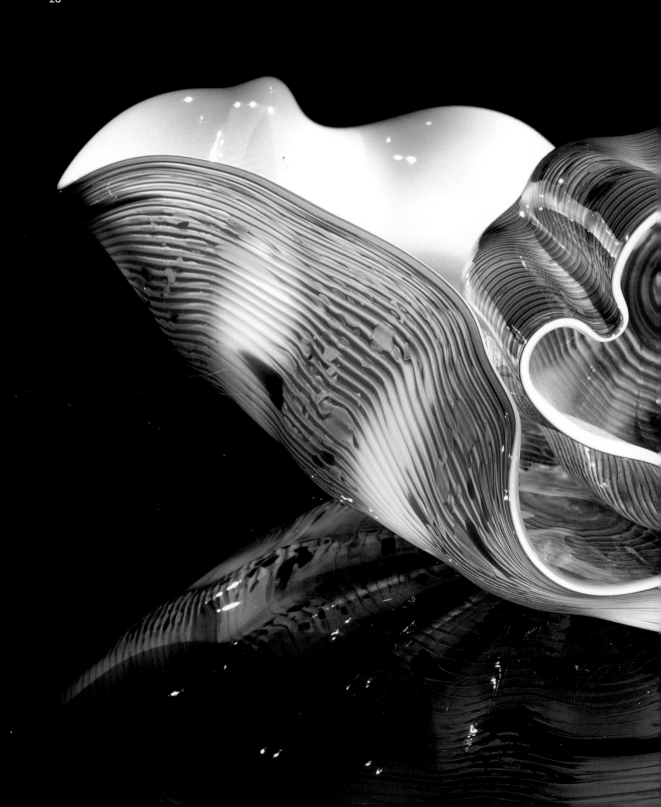

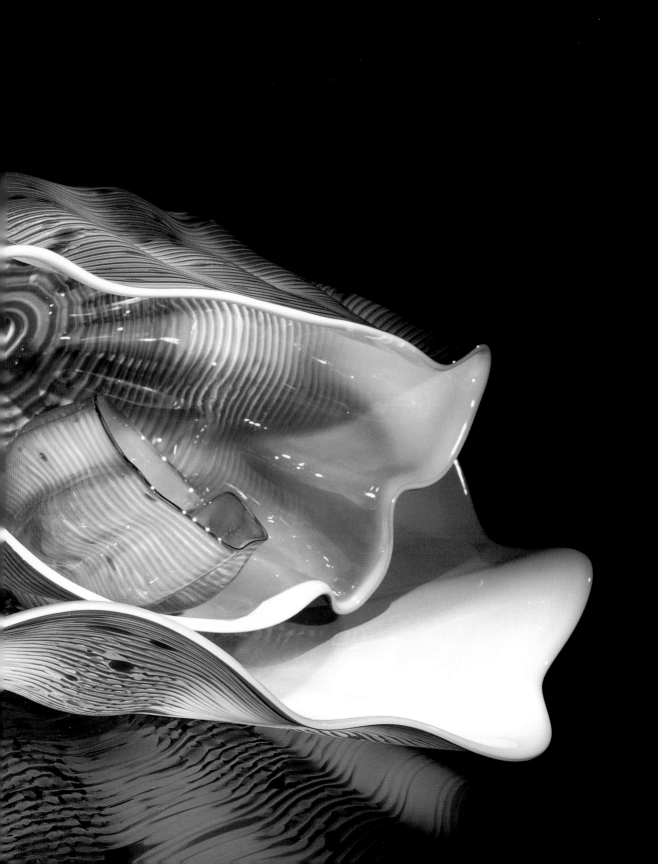

1984 Rose Pink Seaform Set with Celadon Green Lip Wraps, 6 x 19 x 16"

1982 Ecru and Brown Striped Seaform with Black Lip Wrap, 8 x 14 x 9"

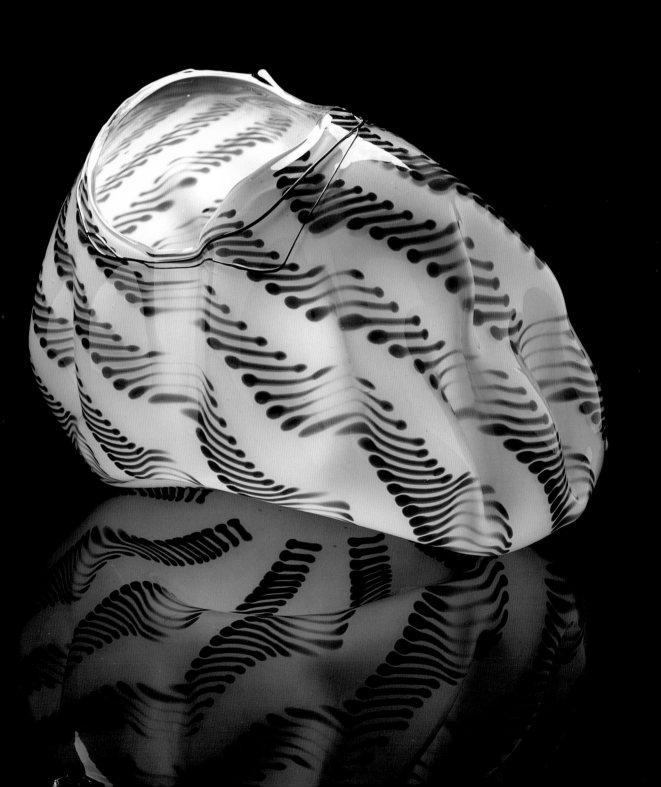

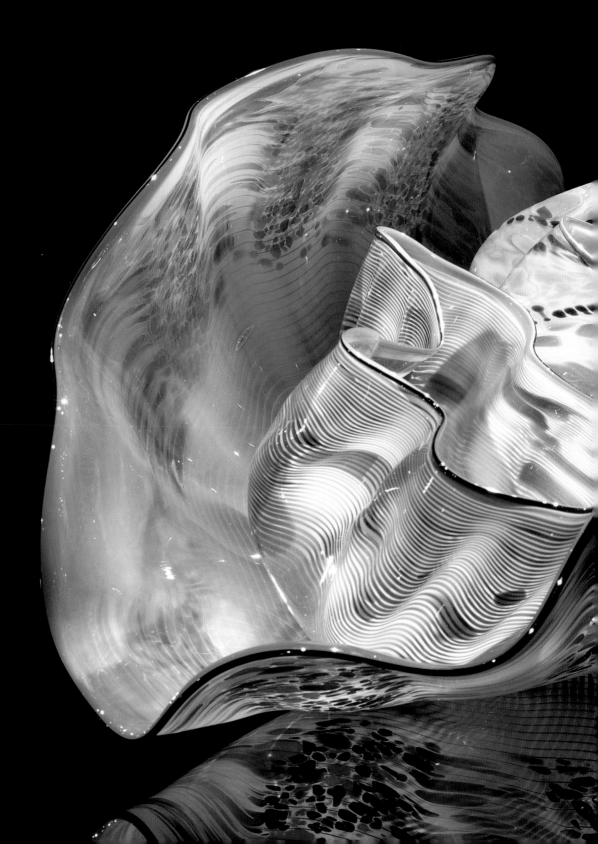

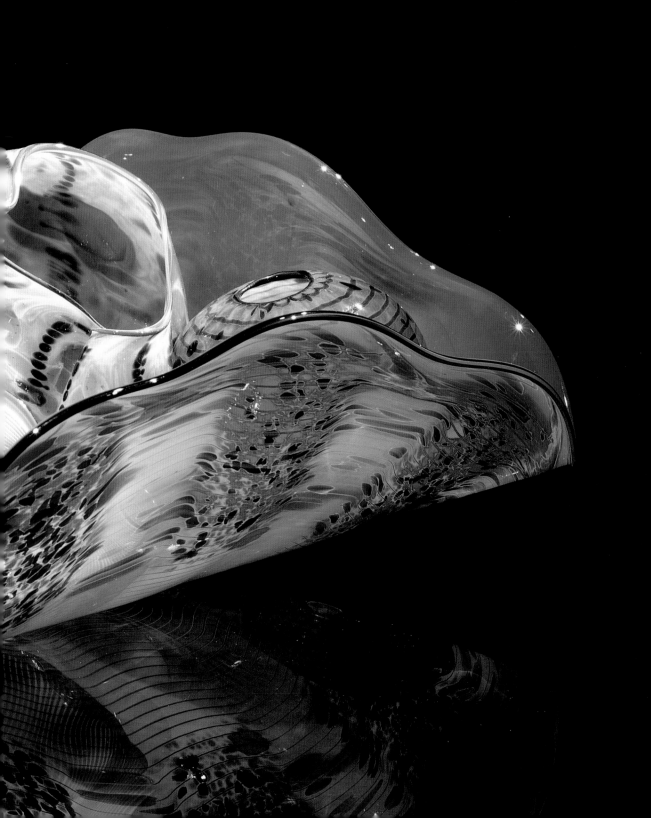

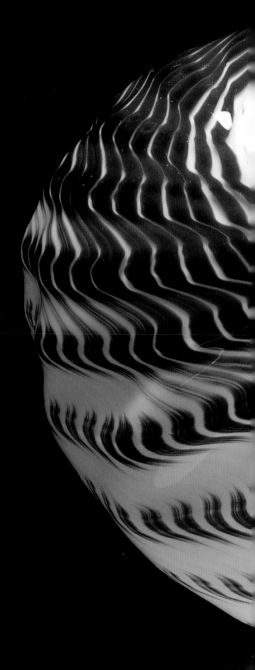

1981 Pink and Lavender Seaform Set with Navy Lip Wraps, 8 x 20 x 10"

1981 Brown Striped Seaform, 4 x 11 x 10"

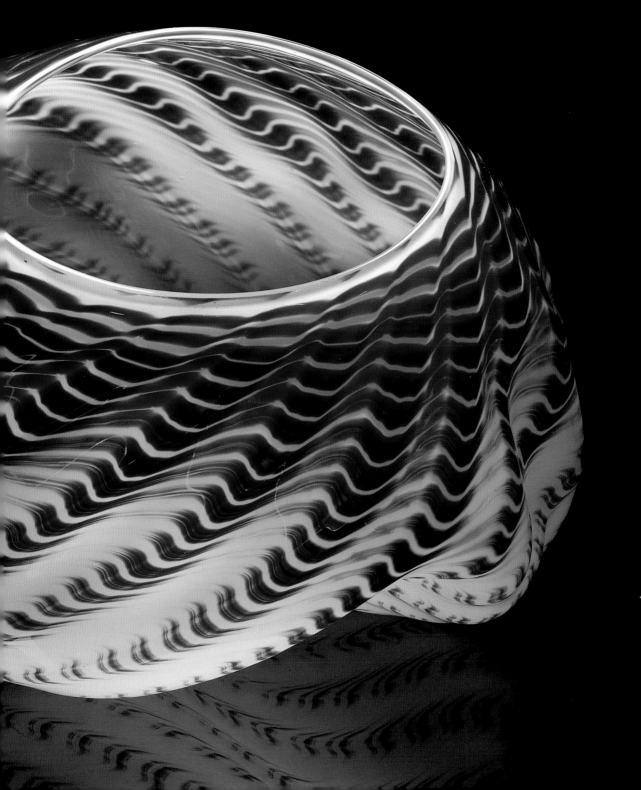

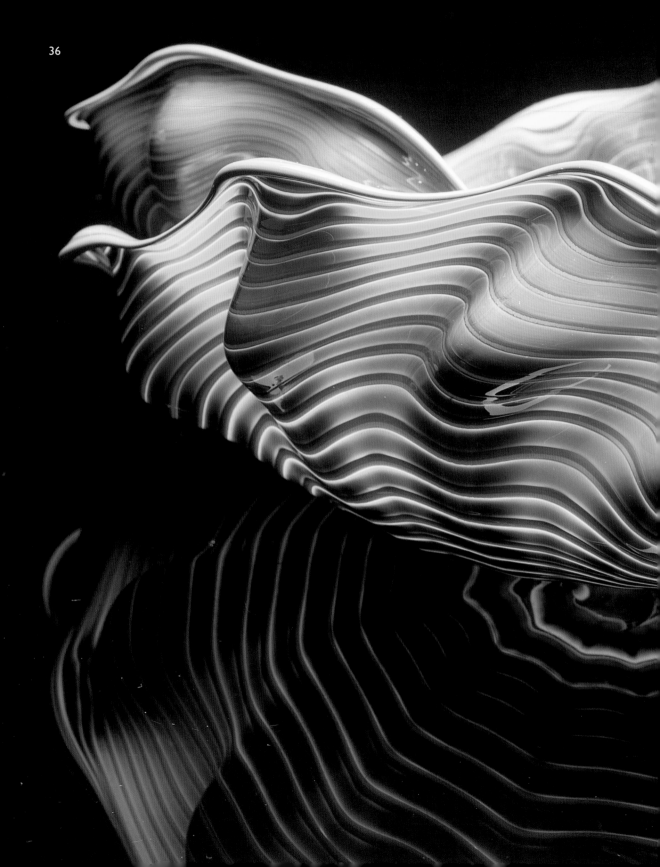

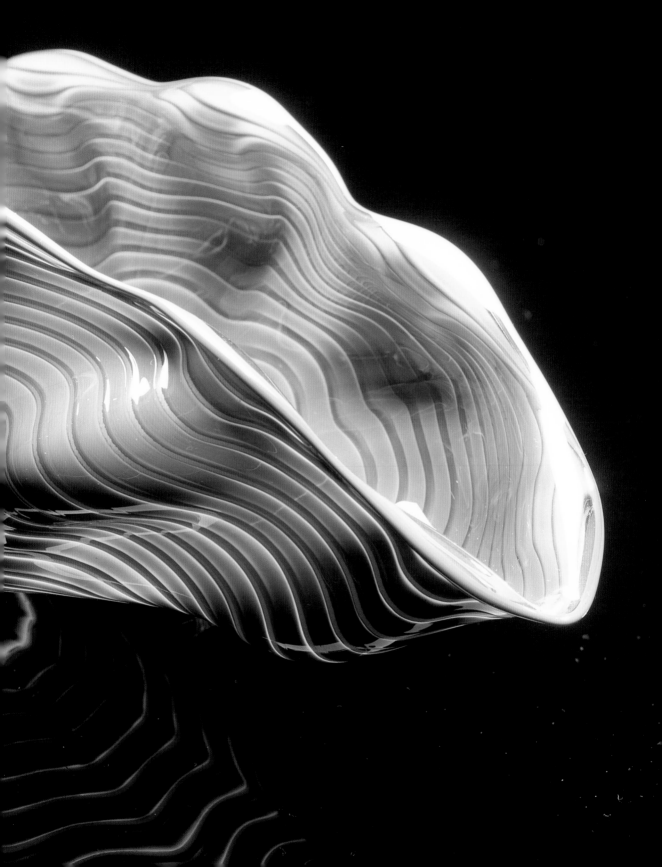

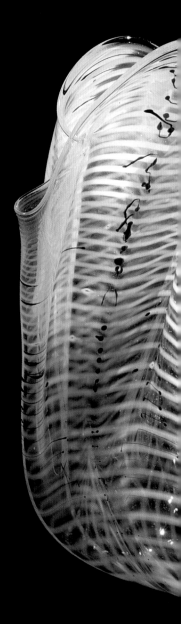

1988 Avocado Green Seaform Set with Green Lip Wraps, 5 x 13 x 7"

1990 Clear White Seaform, 9 x 12 x 11"

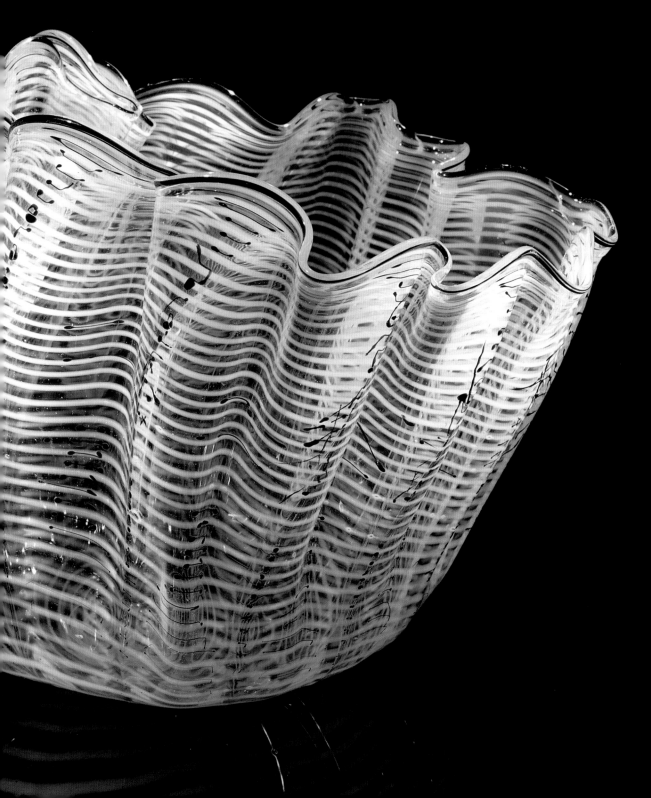

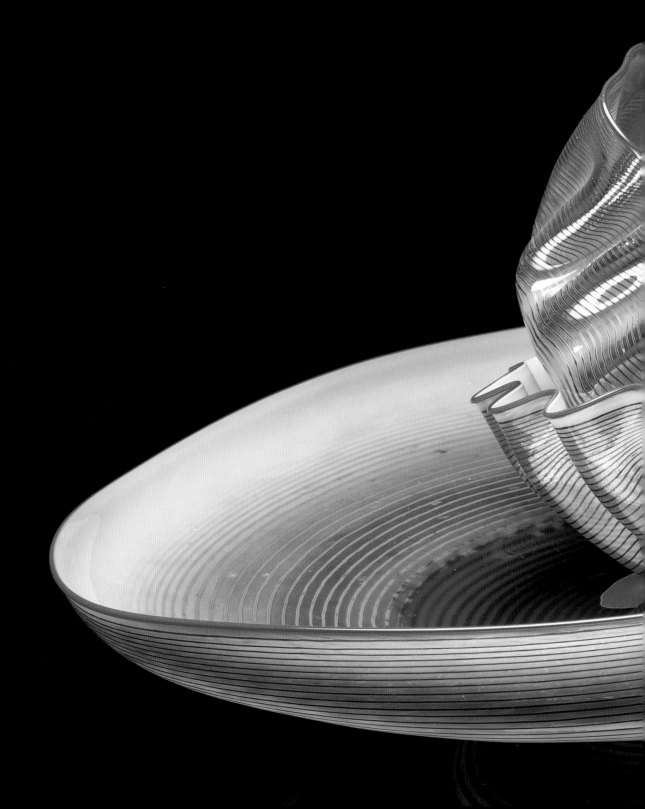

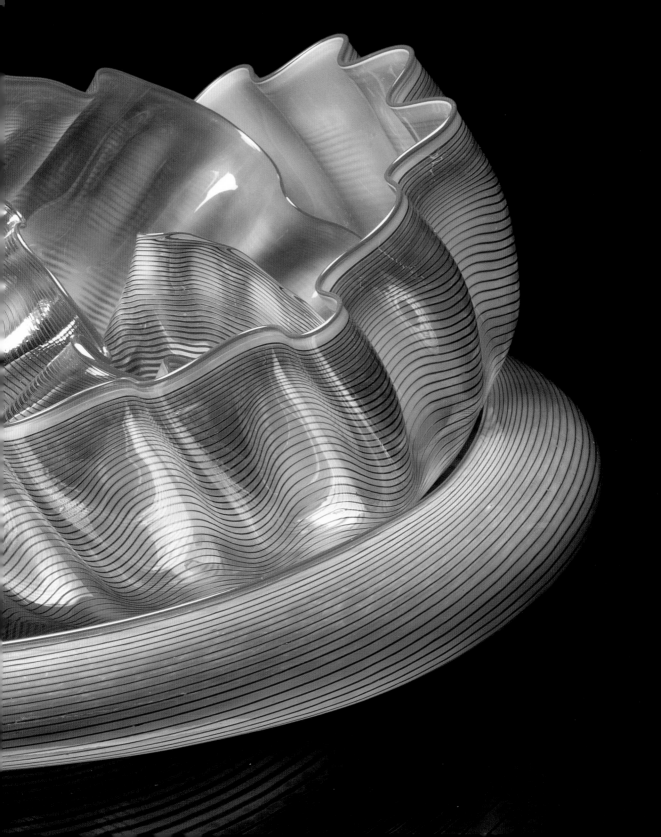

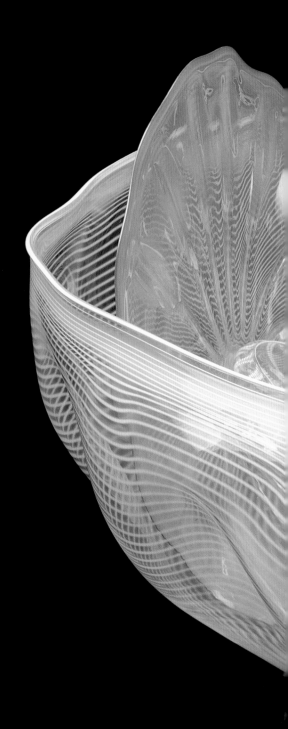

◄ 1983 Pink and Gold Braun Seaform with Red Lip Wraps, 15 x 32 x 30"

1989 Pink Seaform Set with White Lip Wrap, 8 x 12 x 9"

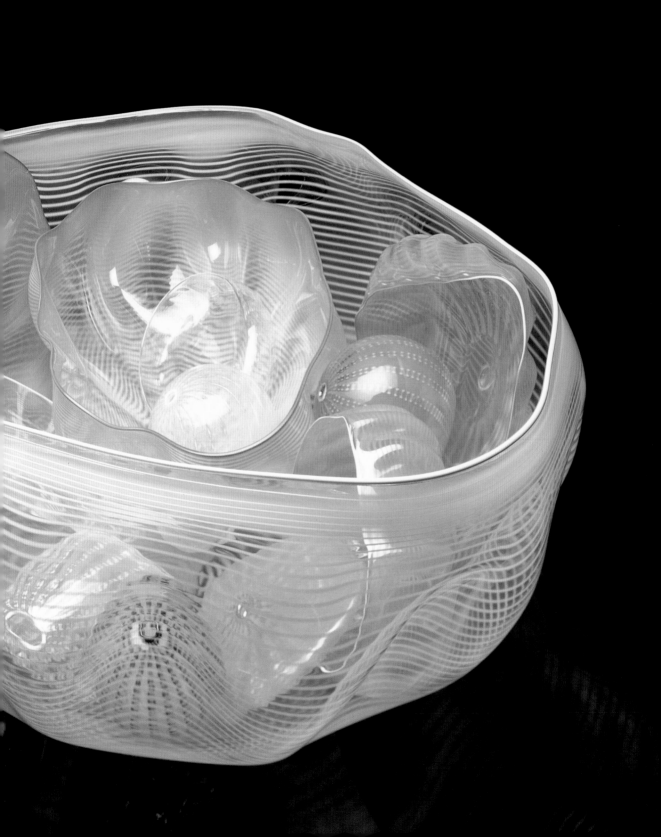

1984 White Seaform Set with Black Lip Wraps, 10 x 20 x 15"

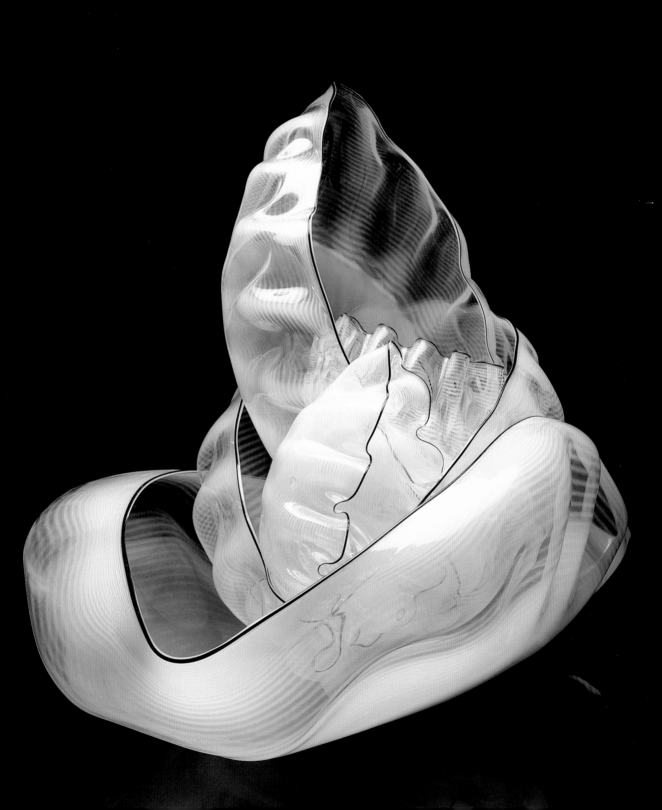

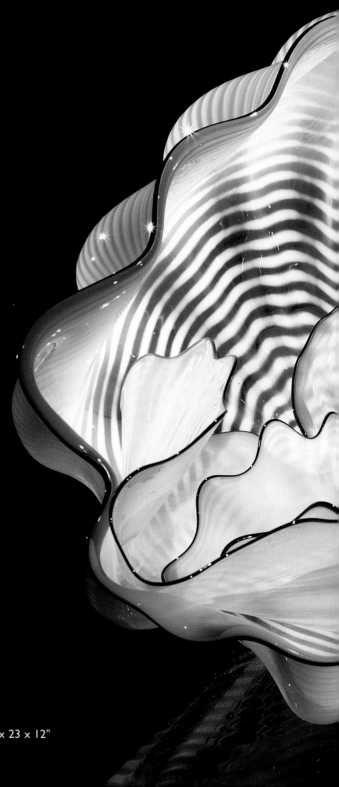

1994 Coral Pink Seaform Set with Black Lip Wraps, 10 x 23 x 12"

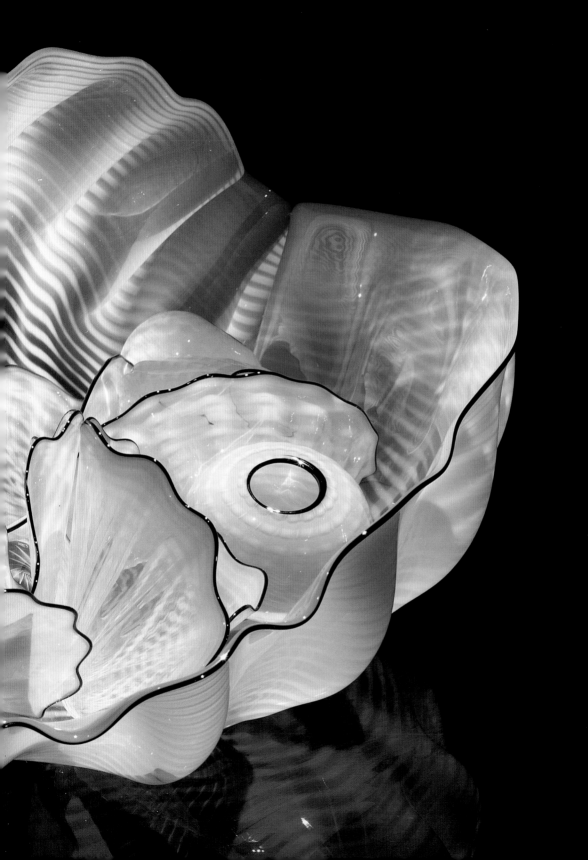

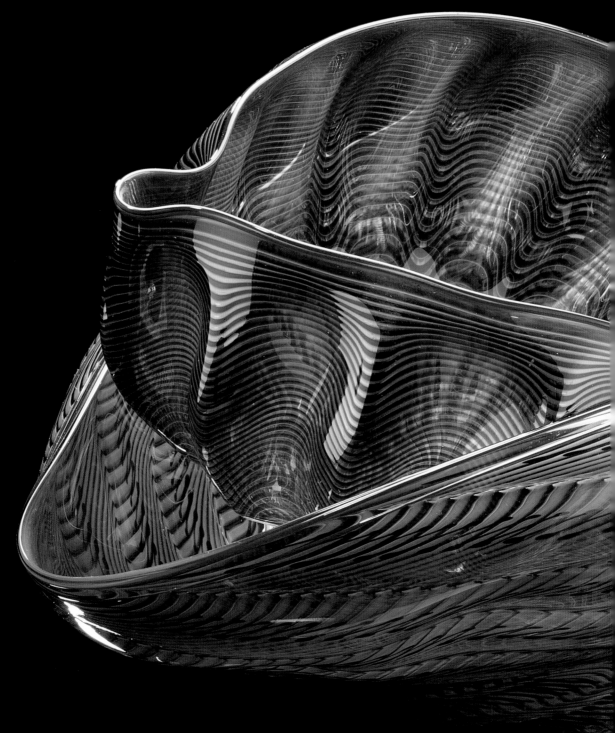

1988 Translucent Oxblood Seaform Set, 5 x 15 x 15"

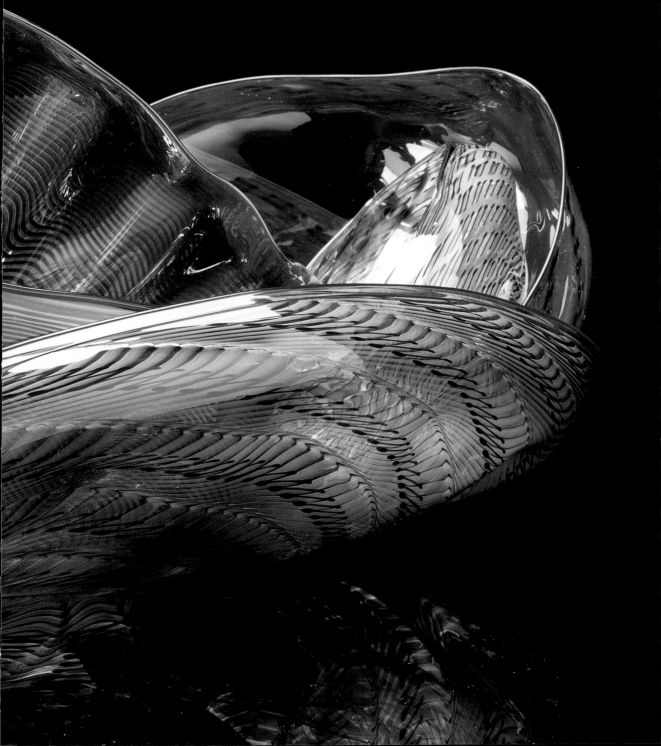

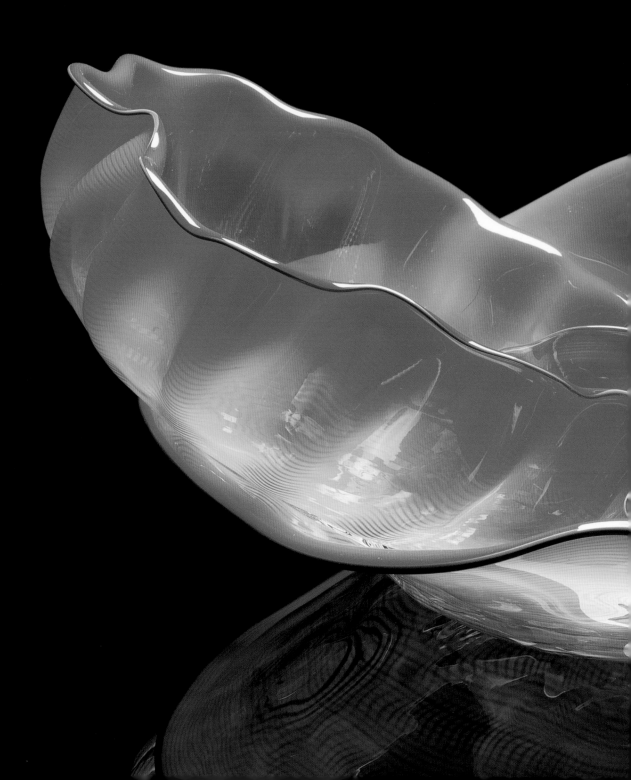

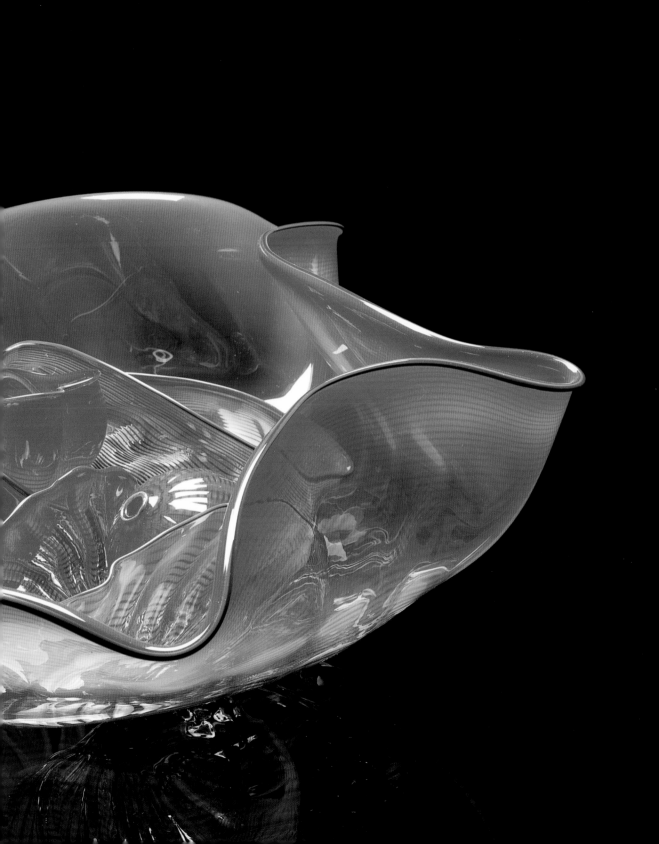

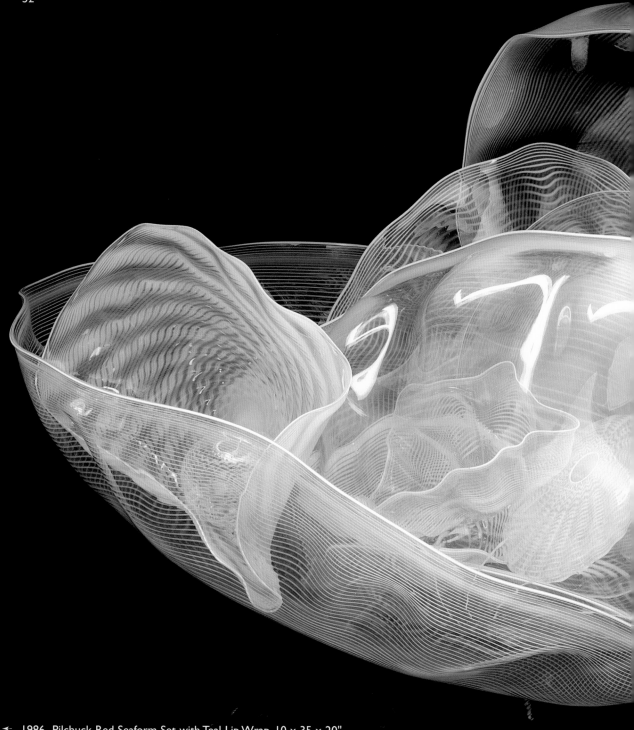

← 1986 Pilchuck Red Seaform Set with Teal Lip Wrap, 10 x 35 x 20"

1985 White Seaform Set with White Lip Wraps, 21 x 22 x 34"

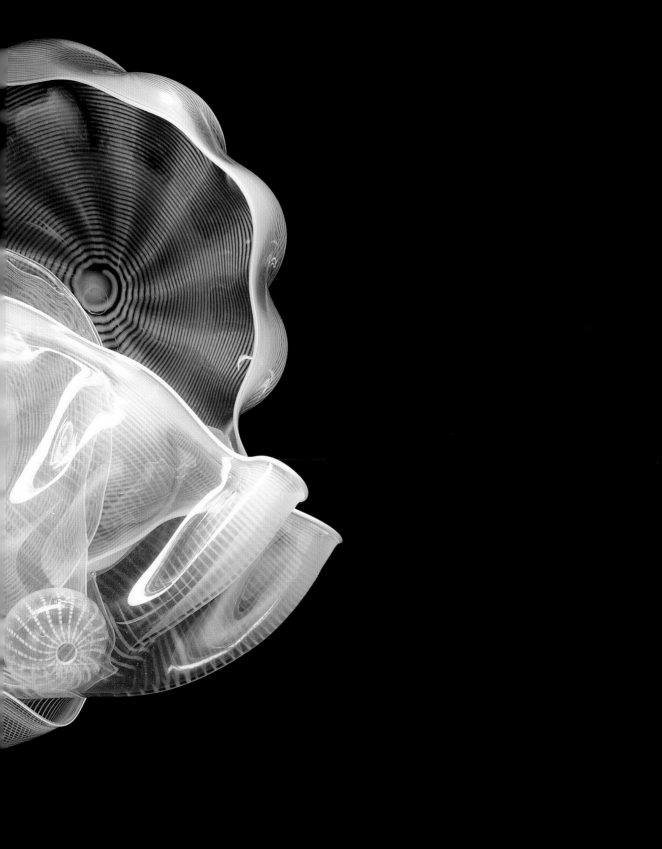

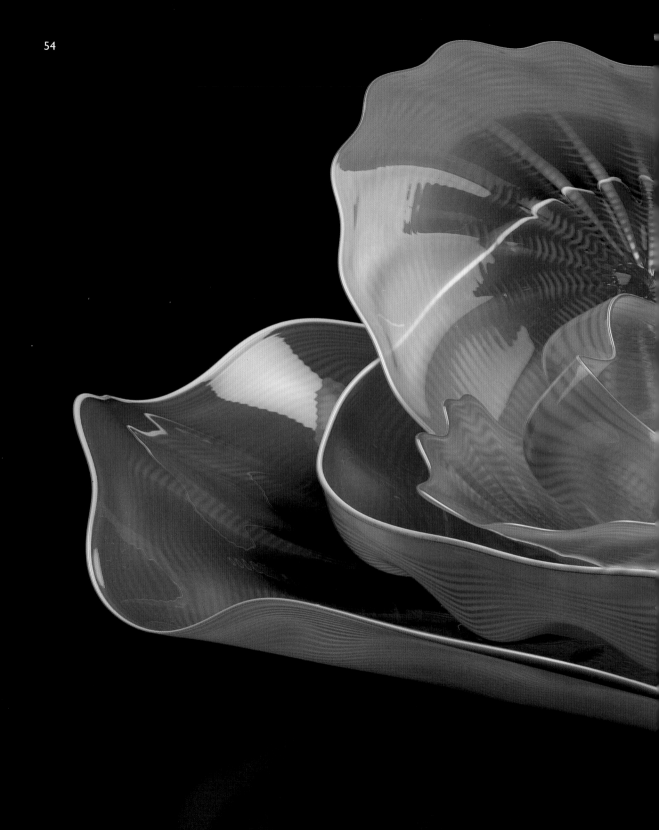

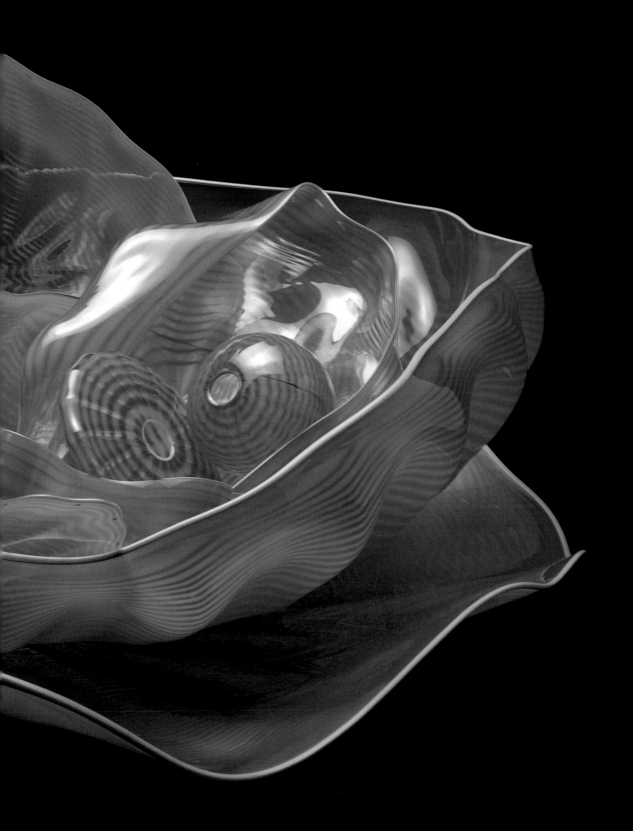

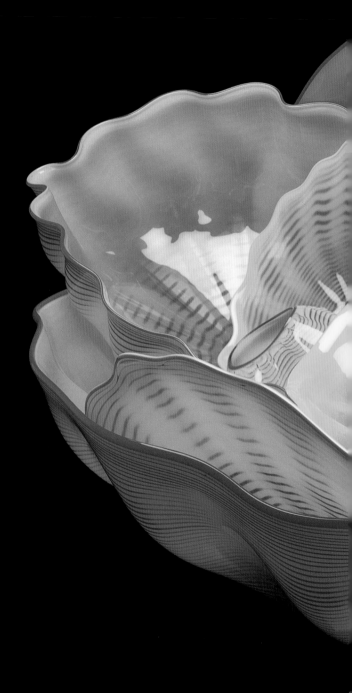

1990 Honeysuckle Blue Seaform Set with Yellow Lip Wraps, 7 x 30 x 27"

1990 Cadmium Yellow Seaform Set with Red Lip Wraps, 13 x 33 x 16"

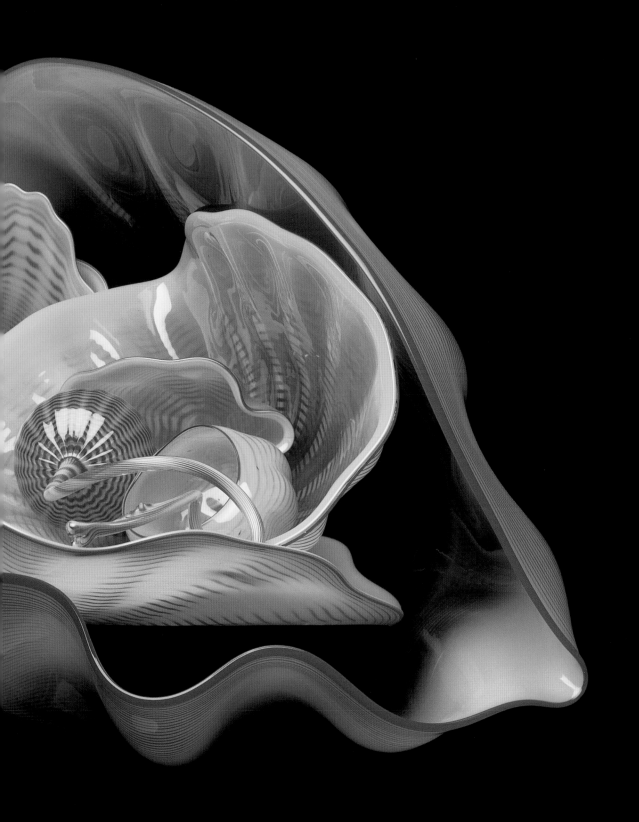

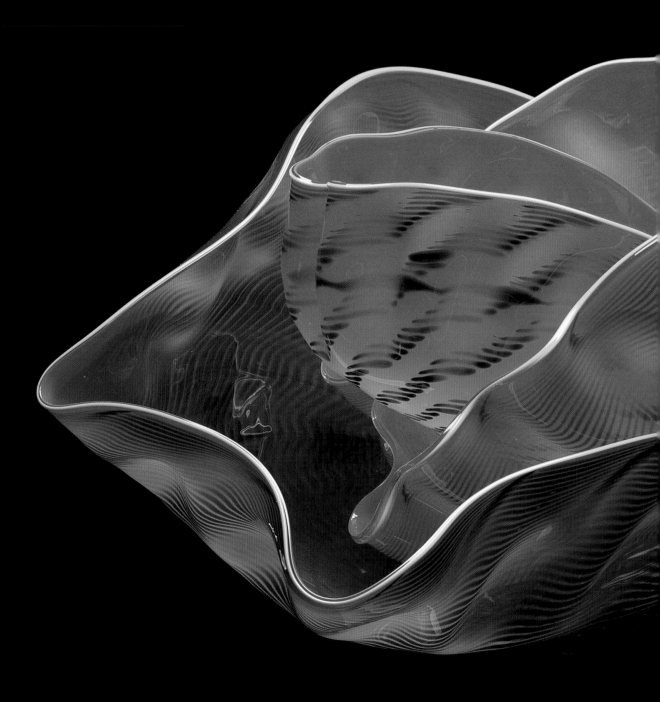

1989 Scarlet Seaform with Yellow Lip Wraps, 9 x 22 x 16"

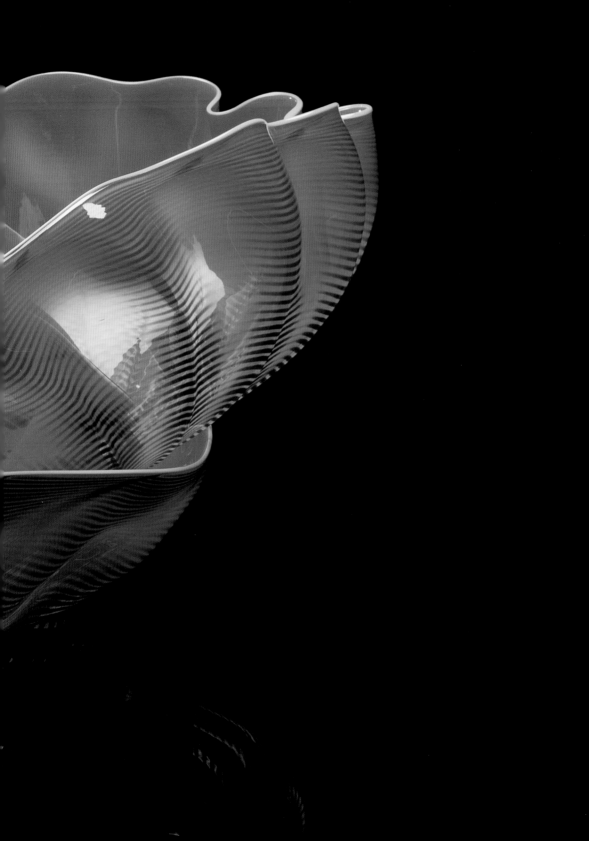

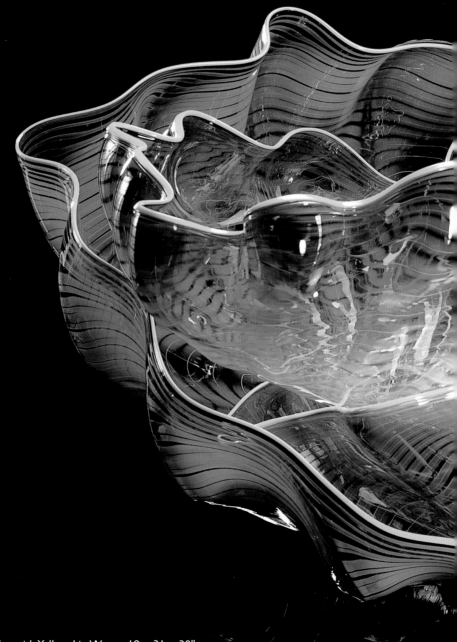

1994 Emerald Green Seaform Set with Yellow Lip Wraps, 19 x 31 x 30"

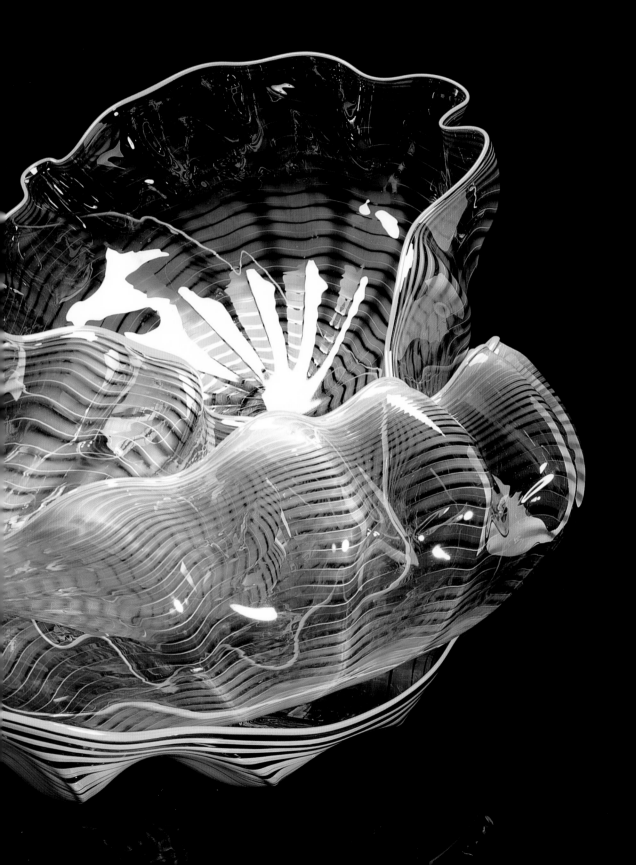

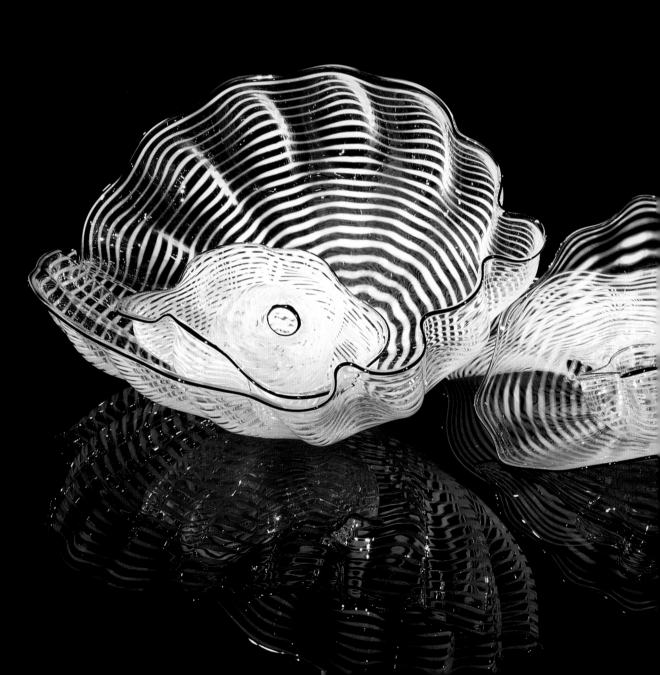

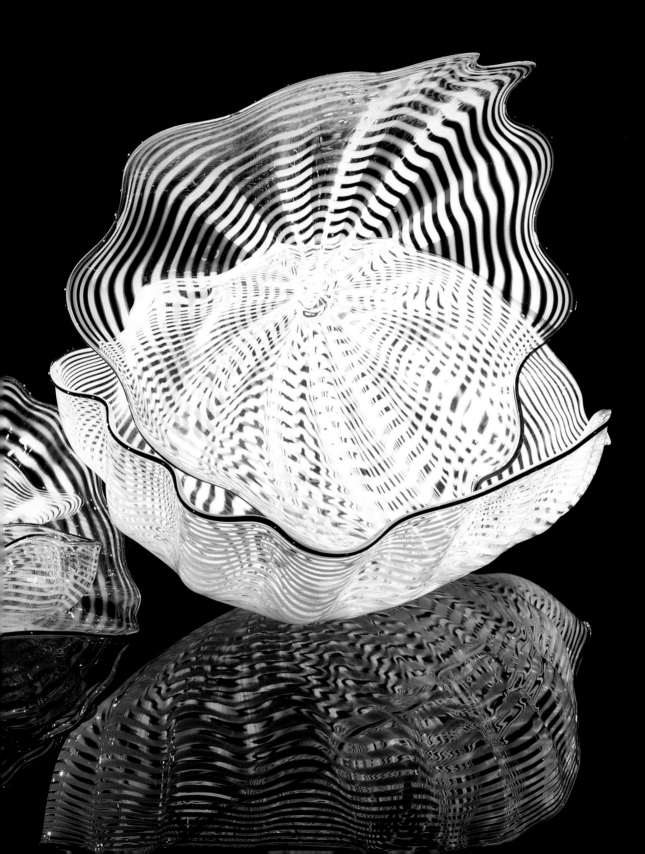

◄ 1992 White Seaform with Black Lip Wraps, 9 x 24 x 14"

1994 Lapis Seaform Set with Yellow Orange Lip Wraps, 16 x 32 x 17"

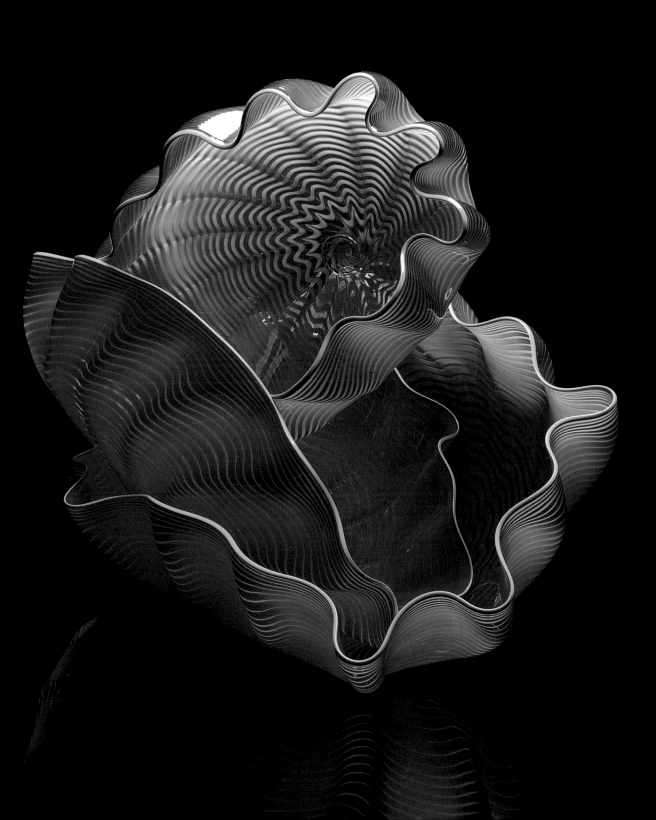

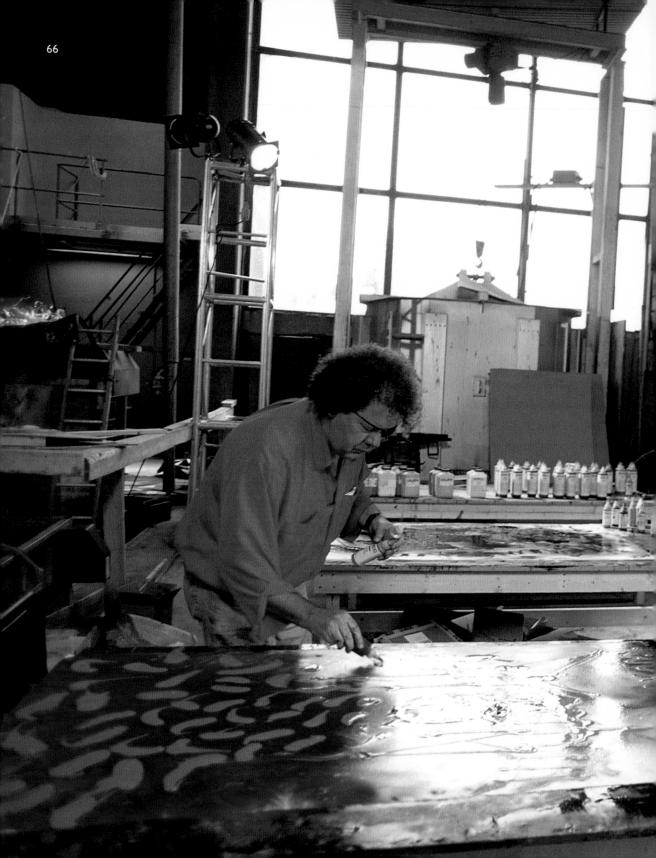

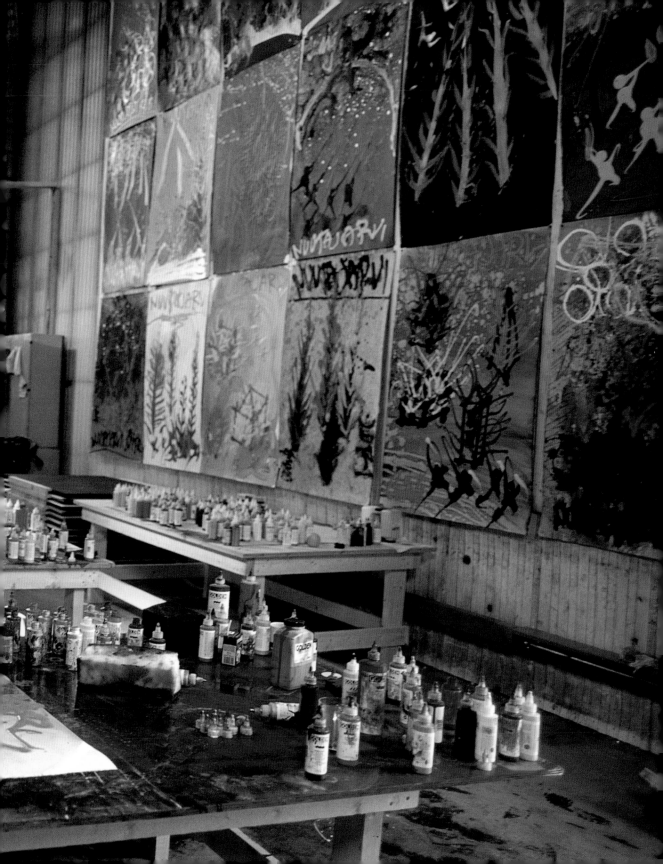

1982
Seaform
Basket
Drawing,
22 x 30",
Watercolor
and Graphite
on Paper

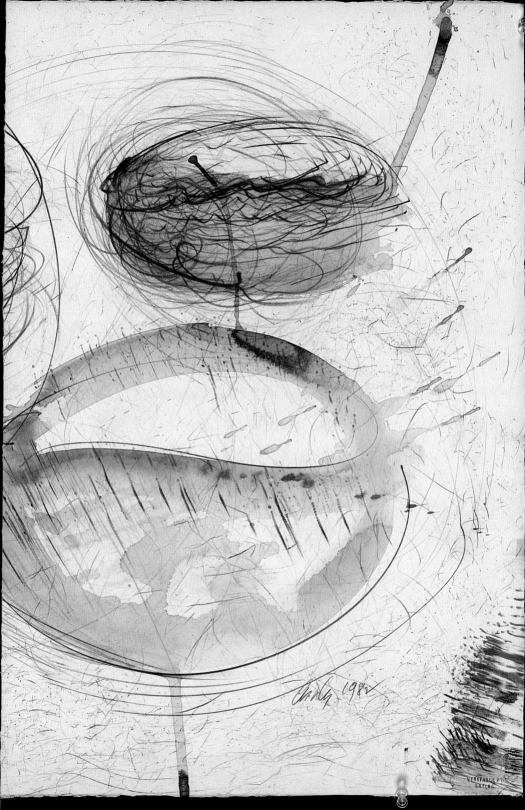

Cimoli 1982

1982
Seaform
Basket
Drawing,
22 x 30",
Graphite
on Paper

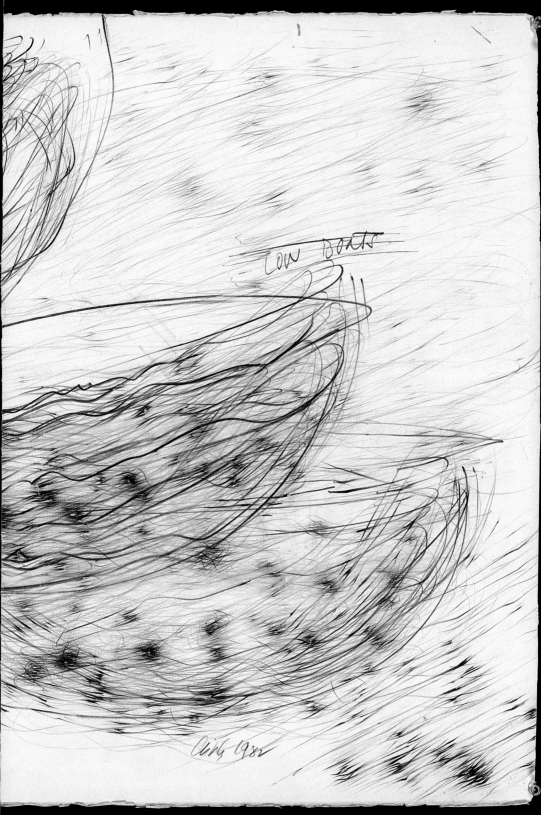

low boats

Craig 1982

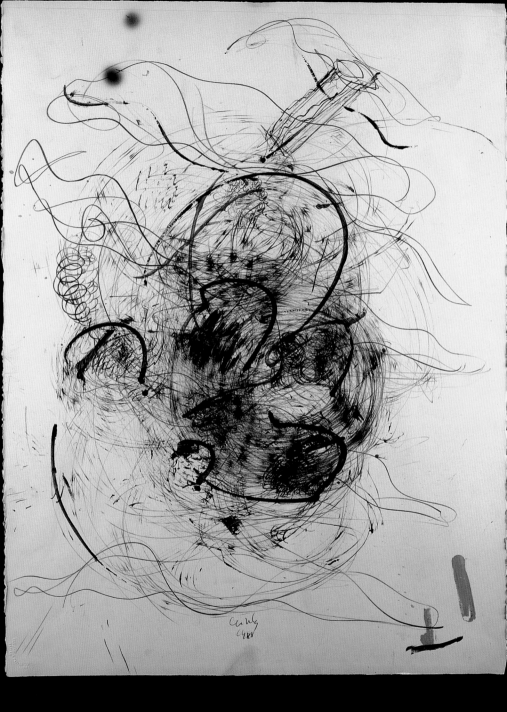

1988 Seaform Basket Drawing, 30 x 22", Ink and Graphite on Paper

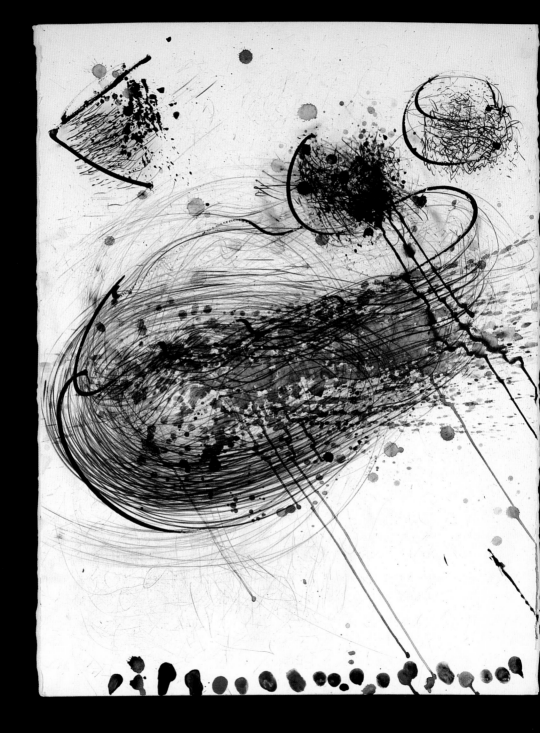

1982 Seaform Drawing #85, 30 x 22", Graphite and Watercolor on Paper

74

1982
Seaform
Basket
Drawing,
22 x 30",
Watercolor
and Graphite
on Paper

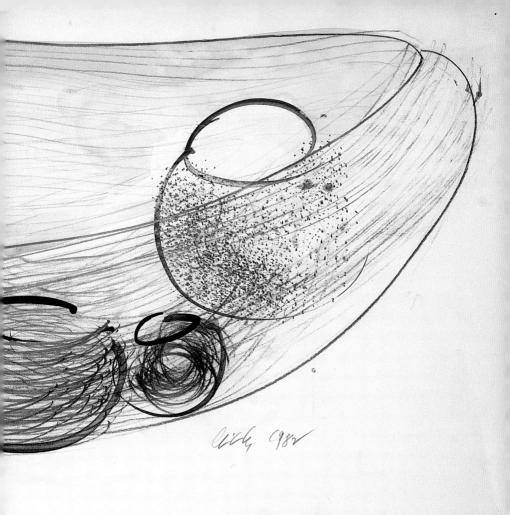

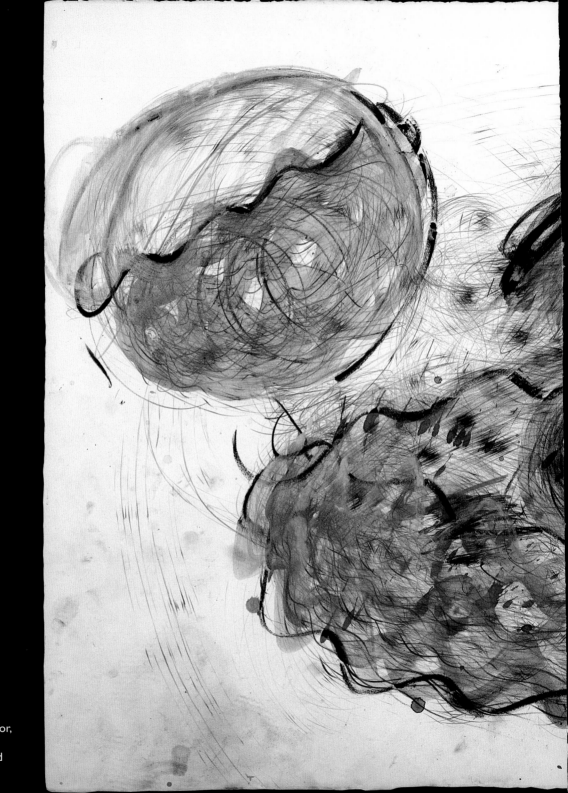

1989
Seaform
Basket
Drawing,
22 x 30",
Watercolor,
Graphite,
Pastel and
Charcoal
on Paper

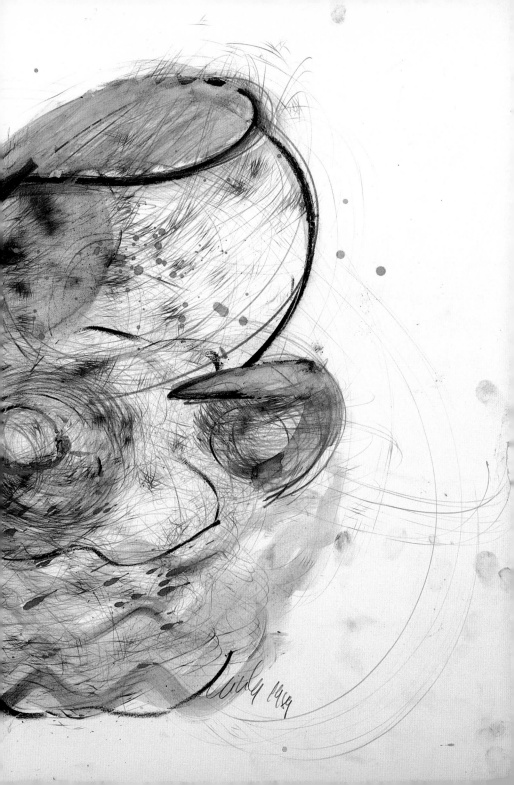

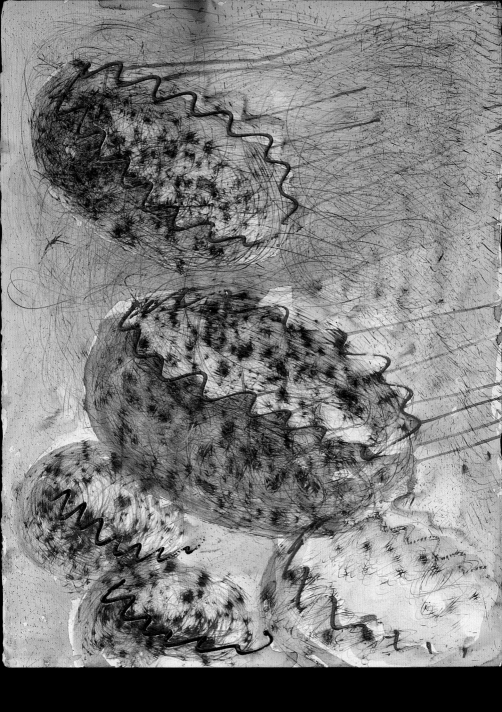

1982 Seaform Basket Drawing, 30 x 22", Graphite and Watercolor on Paper

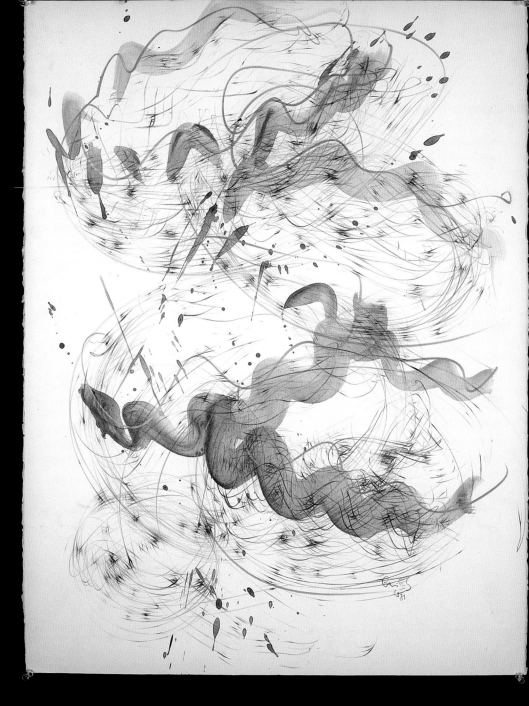

1983 Seaform Basket Drawing, 30 x 22", Watercolor, Graphite and Colored Pencil on Paper

1989
Seaform
Basket
Drawing,
22 x 30",
Watercolor,
Pastel and
Graphite
on Paper

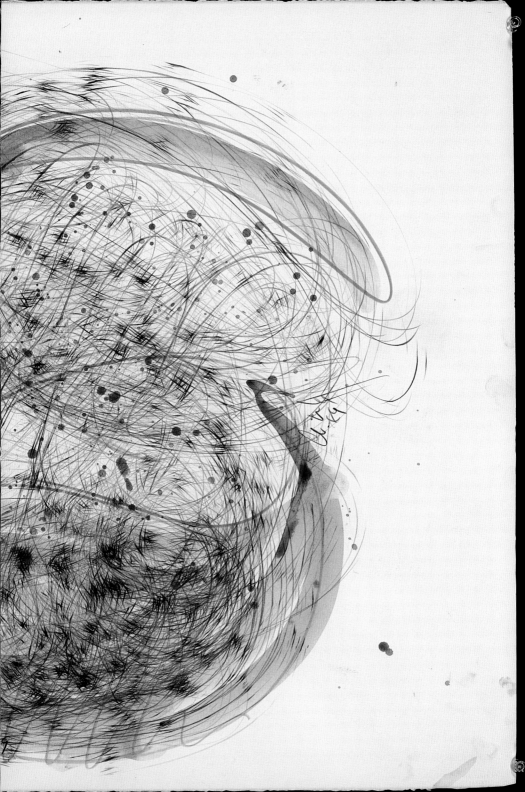

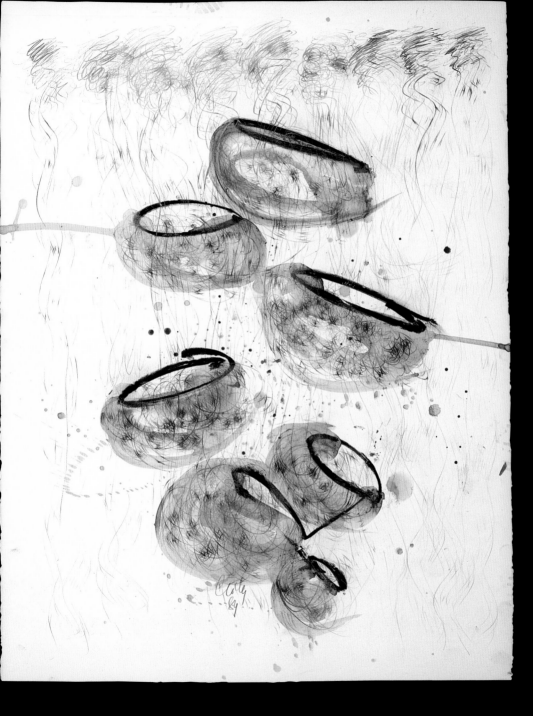

1989 Niijima Drawing #2, 30 x 22", Watercolor and Graphite on Paper

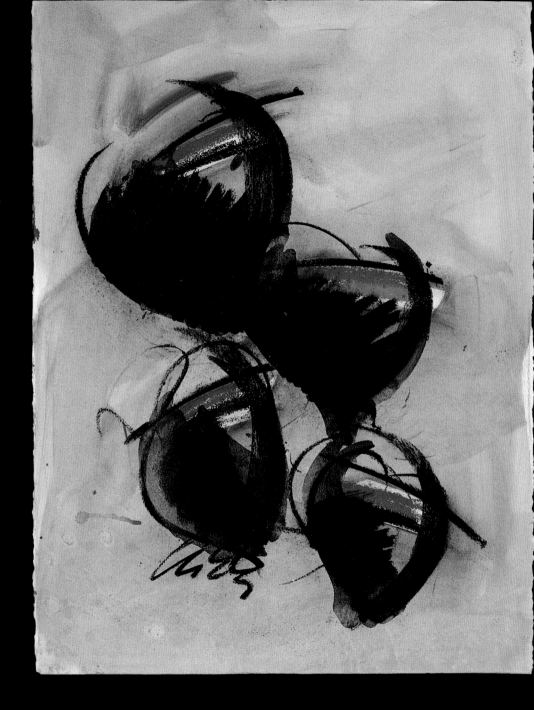

1990 Japan Drawing, 30 x 22", Charcoal, Pastel and Ink on Paper

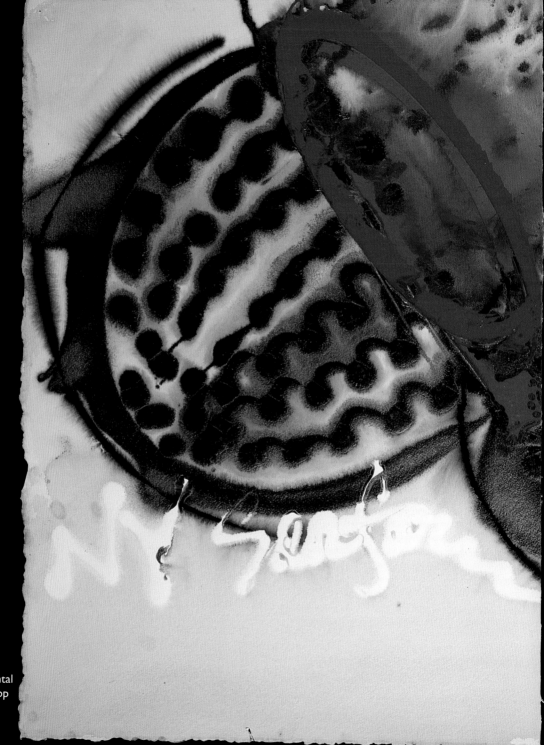

1994
NY Experimental
Glass Workshop
Drawing,
29 x 41",
Acrylic

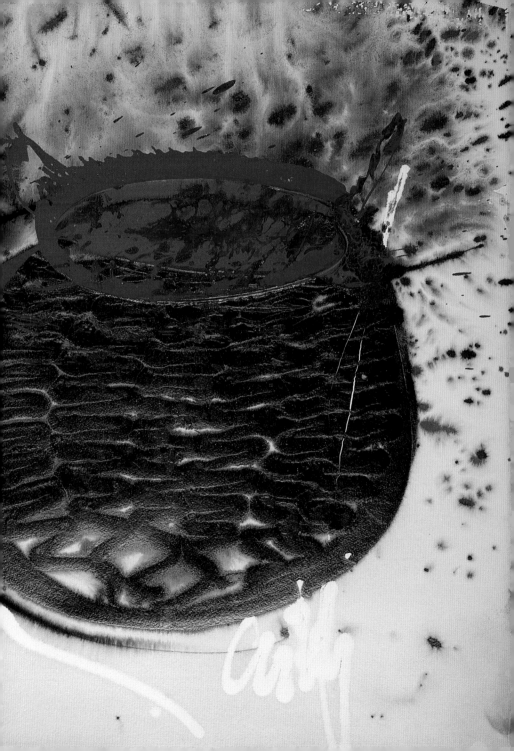

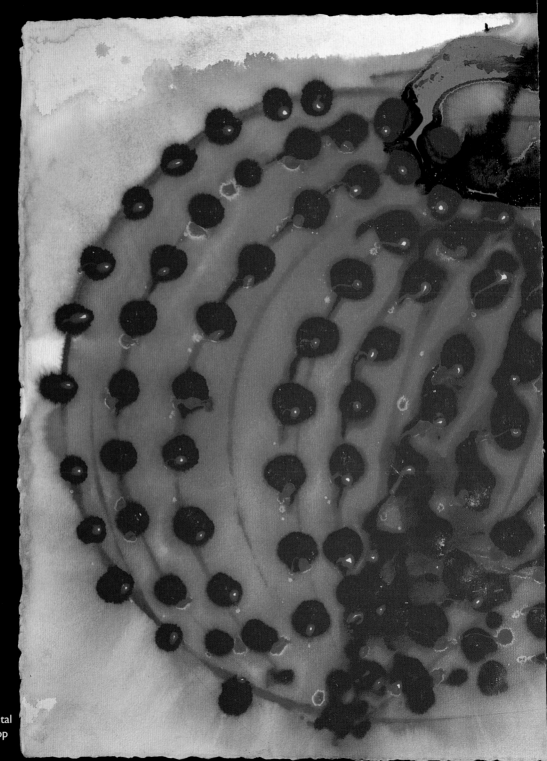

1994
NY Experimental
Glass Workshop
Drawing,

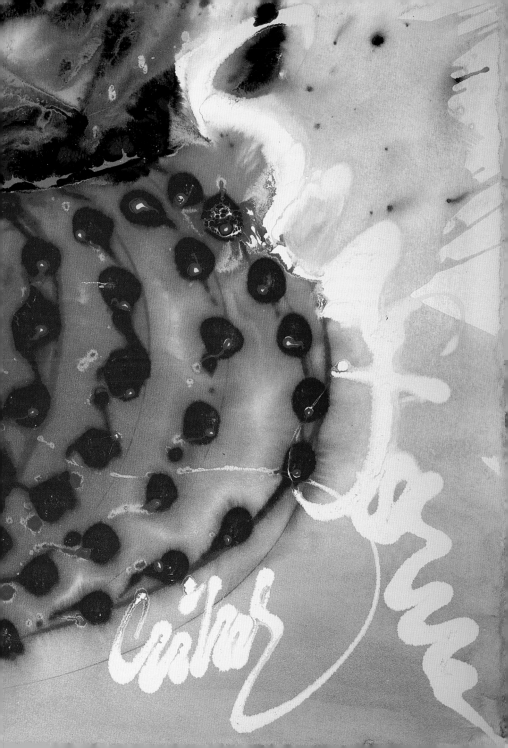

"I remember a critic once writing
that the Seaforms were so buoyant that they
would float to the ceiling during the middle
of the night when the lights were out.
I love that."

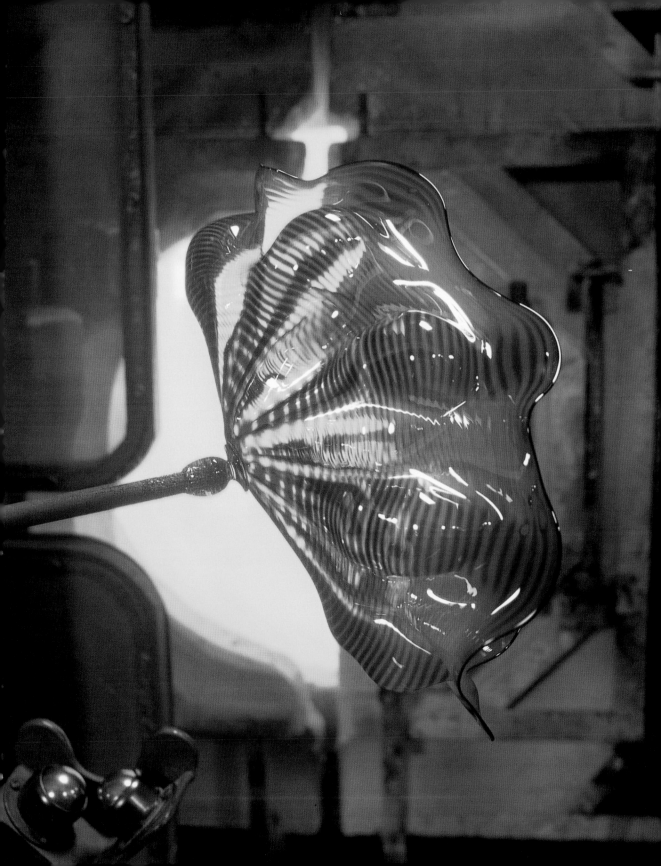

CHIHULY SEAFORMS

by Joan Seeman Robinson

There's a pool in Dale Chihuly's studio in Seattle in which lies submerged, a great bed of *Seaform* sculptures. Lighted from below, their chromatic luminosity irradiates the water, granting it a plenitude as if one were looking into the tropical deep through a glass-bottomed boat. Alone of the four elements — earth, air, fire and water — only water possesses visible mass and simultaneous mutability. It is made visible by fluctuation and what it holds in suspension; it feeds life and breeds organisms that in turn purify and enrich it. No doubt Chihuly, who grew up attuned to the ebb and flow of Pacific waters washing over Tacoma beaches, recognized the harmonious coincidence between his native landscape and the undulant richness of these objects. Thus the "sea forms" emerged, unpredictable configurations filled with an implicit pliancy and an air of mobility.

More than any other of Chihuly's sculptures, the *Seaforms* look like nature's offspring. A vegetal energy radiates from them. They resemble no species of plant, however. And they resist being perceived as containers. Yet their brilliant hues and expanding shapes are directly descended from two previous generations of forms — the erect *Blanket Cylinders* and the billowing *Pilchuck Baskets*, the latter inspired by a collection of Northwest Coast Indian baskets whose slumping bodies and supple resiliency affirmed their organic origin. The Baskets declared Chihuly's desire to free form from classical models, but their walls were delicate, their bodies too fragile for more experimental variations.

Chihuly's technical solution to the problem of fragility appeared literally to generate his own species of "sea life." He sought to strengthen glass by forming it in a grooved mold, reinforcing the fabric much as corrugation adds firmness to cardboard. The glass, now traced circumferentially with radial lines, could withstand a more vigorous manipulation, especially shaking and crimping, which introduced longitudinal ripples and pleats. Watching the process of glass blowing and the effect of gravity on the hot and supple materials is like witnessing a time-lapse recording of proliferating sea life, the glass forms germi-

nating like palpable living organisms. The resultant shape of the *Seaforms* is a whorl of arabesques springing outward from a source, which no longer resembles or conforms to the bottom of a pot. In fact, there is no sense of "ponderation," of weight distributed centrally and securely. Because their shapes are so amorphous and irregular, their walls so convoluted and their contours so elaborate, they refute classical balance, achieving a kind of delicate equipoise.

Chihuly's art is an art born of process. He exploits the spontaneity of the glass-blowing medium and embraces it rather than trying to subjugate it to his will as traditional craftsmen have done. Chihuly approaches the act of drawing in the same manner. He doesn't draw to provide models for his team to replicate but to celebrate the spontaneity of the medium, just as in the process of glass blowing. He sweeps swaths of color on papers laid out like stepping stones on the deck outside his studio, a converted racing scull factory called the Boathouse, on the waters of Lake Union. The glass *Seaforms* reflect the "gestural mapping" of his drawings and the full-bodied energy that goes into their making. The sculptures, by reaching out to the space around them, infer "fields" and are clearly related to an aquatic sensibility in modern painting in which seemingly unmediated and unpremeditated streams of lines and flows of pigment appear to spring directly from the artist's psychic state. The development of Chihuly's *Seaforms* partakes of this intuitive procedure, its roots extending back to the primal impulses that emerged in the Surrealists' automatic drawings and paintings in works like Andrè Masson's <u>Battle of the Fishes</u>, Joan Miró's <u>Birth of the World</u>, and the hydromorphic creations of the American painters, Theodore Stamos, William Baziotes and Nassos Daphnis in the early '40s. Unlike many contemporary artists, he is not an avid student of art history, but has responded to formal concerns in ways that recall his aesthetic forebears.

The *Seaforms* and their offspring, the huge suspended waves of clustered

glass that he installs across walls and windows, have their most ambitious antecedents in Claude Monet's water lilies, especially those of such breadth that they reach beyond peripheral vision. The goal for Monet was not to make a work with no boundaries, one that suggested an infinite extension, but to invoke the effect of a great pond, its surface patterns and reflections animated by light and air. And Miró, in his largest murals, summoned whole constellations of sprightly characters in magnetic suspension across glowing skies. Jackson Pollock in One and Blue Poles is closer to prefiguring Chihuly's own gestural approach, through flowing lines and shapes executed in broad body movements over a surface spread out on the floor — a kind of choreographic record of an inspired working state.

But perhaps it is Henri Matisse's Swimming Pool that is closest to Chihuly's achievement in the Seaforms. Matisse loved the Mediterranean, especially for its light. He even went to Tahiti in the South Seas, optimistically anticipating a productive creative period. But finally it was in his studio when he was bedridden in his late years that he conceived of The Swimming Pool, a work of fragmented blue arabesques streaming lengthwise some 54 feet across a continuous white panel. The Swimming Pool was a dream of buoyant immersion, of swimmers' bodies so propulsive and their visibility so elusive that only traces of their emergence made sense of the sensations — both of partaking in and witnessing what the experience is like. The Swimming Pool was made of individually cut pieces of painted paper whose positions were plotted and adjusted intuitively entirely in relation to an overall scenario; an aquatic experience reconvened and reconfigured and installed on four walls in order to transform a room — thus becoming a kind of therapeutic fantasy, aestheticized, idealized and held in permanent suspension.

In the Seaforms, Chihuly succeeds in sustaining an aura of ineluctable transformation. The very process of making reinforces their implicit sense of life.

Centrifugal force opens them up, just as a living organism expands with breath. The glass also "remembers" the lines imprinted by the ridged or optical mold, creating longitudinal ribs that reveal the webbed delicacy of their walls. When the bodies become more transparent, their linear infrastructure is exposed like a skeletal network. And the faint films of thinned colors, the lapidary reds, greens, violets, blues and yellows, suggest membranes and tissue.

The individual works have a formal integrity, a sense of wholeness and resolution. There are also families of *Seaforms*, large vessels with smaller and smaller shapes nestled within them, which can seem as different as night and day. A yolky chrome yellow set whose lips are so densely pigmented that they look like butterscotch, seems charged with heat, its borders framed with a fiery red. Another group in deep cobalt blue seems to draw in and swallow light. Translucent, it nonetheless seems impenetrable as though made of dense shadows, its cool nocturnal quality heightened by the yellow blips with which each rim is traced—like someone moving through darkness carrying a dancing flashlight. Occasionally a *Seaform* will have a deep tulip-like bowl, but it will be thrown eccentrically off course like a tissue-thin water blossom tugged by a tide.

As self-sufficient and elegant as the *Seaforms* can be, they are part of the larger scope of Chihuly's vision, which is to alter the environment. His isn't a political agenda, intended to inform us of complex ecological issues. But neither is it resistant to such associations, for it reminds us of how we may feel in the presence of nature and the wonder that stirs us at its evanescence and vulnerability. For in the fragility of glass, there is also a pathos—a projection of our longing for harmony, serenity and, at least, a quotient of spirituality and, at the same time, a forewarning of loss because loss seems integral to the material. It is the essence of glass to forecast its own disappearance and to embody its own immateriality.

The *Seaforms* call forth associations with water, marine life and movement

without depicting *them* and that's why they so persuasively affect us as art. Certainly as craft they are impressive and intriguing. If they are art it's because something prompts us to probe why they move us so, and therefore to attempt to consider the causes of this influence. Chihuly didn't assign himself the subject of "sea forms." The appellation came forth because their fluidity seemed paramount.

To free glassmaking to this degree, to liberate form to such an extent that it appears to be returning to its own more primitive or organic state — indeed, to be in the process of perpetually evolving within that state is the real achievement. That Chihuly's works seem both impossible and alive is not so much confounding as convincing. Because, of course, they are really at rest and possessed of a clarity of form, they seem to arrest the ineffable. With all their richness of suggestion, they succeed in condensing the transient, the exotic and the intuitive, idealizing, as it were, the phenomenally subliminal and mysterious. (This is not to infer that there's a dark side to the *Seaforms*. That's a subject due his later series, the *Niijima Floats*.) The *Seaforms* are inclusive and outreaching. Their forms, skins and pigmentation seem innocently offered. We see through them. They open up and curl in a kind of voluptuous solicitation, restorative and generous, in a sensuous repose. Their initial seductiveness is more than skin deep. Their concentrated vitality and unvarying accessibility assure us that our delight in their presence offers a deeper awareness of a similar potential in ourselves.

Joan Seeman Robinson is a freelance writer who regularly contributes to <u>Artforum</u>.

CHRONOLOGY

1941 Born September 20 in Tacoma to George and Viola Chihuly

1957 Only sibling, George, dies in naval aviation accident

1959 Father, George Chihuly, butcher and union organizer, dies

1962 Begins first experiments with fused glass in Seattle

1962-3 Travels to Europe and Near East; lives on Kibbutz Lahav in the Negev Desert
 Weaves first "Glass Tapestries" at the University of Washington

1964 Makes first trips to Ireland and Russia

1965 Meets Jack Lenor Larsen
 Graduates from the University of Washington, BA, Interior Design
 Awarded Fulbright to study weaving in Finland
 Quits design job and travels to Alaska to work as a fisherman

1966 Studies glass blowing under Harvey Littleton at the University of Wisconsin

1967 Meets Italo Scanga at the Rhode Island School of Design (RISD), Providence
 Begins large-scale glass installations
 Makes first use of neon inside blown forms

1968 Teaches first time at Haystack Mountain School of Crafts, Maine
 Receives MFA, RISD
 Receives Louis Comfort Tiffany Foundation Grant
 Receives Fulbright to work at Venini on Murano

1969 Travels to Czechoslovakia to find the Libenskys
 Travels to Germany to find Erwin Eisch
 Establishes the RISD Glass Department

1970 Begins four-year collaboration with Jamie Carpenter
 Makes first ice-and-neon project

1971 Starts Pilchuck Glass School with Anne Gould Hauberg and John Hauberg

1972	Travels to Mexico with Jamie Carpenter and Barbara Vaessen
	Returns to Venice to work at Venini with Jamie Carpenter
1974	Makes last collaborative piece with Jamie Carpenter, "Corning Glass Museum Wall"
	Tours European glass centers with Tom Buechner, director of the Corning Museum of Glass
1975	Begins "Blanket Cylinders" with Kate Elliott and Flora Mace fabricating patterns
	Collaborates with Seaver Leslie on "Ulysses Cylinders" and "Irish Cylinders," with Flora Mace fabricating patterns
1976	Loses sight in left eye in serious auto accident in England
	Curator Henry Geldzahler purchases "Navajo Blanket Cylinders" for Metropolitan, NYC
	Begins to exhibit in commercial galleries
1977	Begins "Basket" series at Pilchuck
	Charles Cowles curates "Carpenter, Chihuly & Scanga" at the Seattle Art Museum
1978	Exhibits "Baskets & Cylinders: Recent Work by Dale Chihuly," Renwick Gallery, Washington, DC
1979	Begins working with Billy Morris at Pilchuck
1980	Resigns RISD faculty post and becomes artist-in-residence
	Begins "Seaform" series
	Installs stained glass windows at Shaare Emeth Synagogue, St. Louis
1981	Begins "Macchia" series with Billy Morris as gaffer
	Demonstrates in glass centers of Europe with Billy Morris
1983	Relocates to Seattle and Pilchuck
1984	"Chihuly: A Decade of Glass" begins North American tour
1985	Renovates Buffalo Shoe Building as studio
1986	Receives honorary doctorate from the University of Puget Sound, Tacoma
	Receives honorary doctorate from RISD
	Returns to "Cylinder" series with new "Soft Cylinders"

Begins "Persian" series with Martin Blank as gaffer
"Dale Chihuly: objets de verre" begins European and Middle Eastern tour

1987 Donates retrospective "Chihuly Collection" to the Tacoma Art Museum
in honor of brother, George Chihuly, and father, George Chihuly
Installs "Rainbow Frieze" in Rainbow Pavilion, Rockefeller Center, NYC

1988 Receives honorary doctorate from California College of Arts and Crafts, Oakland
Begins "Venetian" series with Lino Tagliapietra as gaffer
"Persians," curated by Henry Geldzahler, begins North American tour

1989 Has solo exhibition, "Chihuly Glass," at the Bienal de São Paulo, Brazil

1990 "Dale Chihuly: Japan 1990" opens in Tokyo
Begins incorporating "Putti" into work using Pino Signoretto as gaffer
Renovates Pocock racing shell factory as Boathouse studio/home

1991 Begins "Niijima Float" series with Rich Royal as gaffer
"Chihuly: Venetians" begins European tour in Prague
Begins "Ikebana" series
Completes "Tea Room Installation" in Yasui Konpira-gu Shinto Shrine, Kyoto

1992 Honored as first "National Living Treasure" by United States governors
"Dale Chihuly: Installations 1964-1992" begins US tour at the Seattle Art Museum
Begins "Chihuly Chandelier" series, first shown at Seattle Art Museum

1993 Designs sets for Debussy's "Pelléas et Mélisande" for the Seattle Opera
"Chihuly: Form from Fire" tours US
"Chihuly in Australia: Glass and Works on Paper" tour begins in Sydney
"alla Macchia" tours US
Becomes spokesperson for Very Special Arts
Named Alumnus Summa Laude Dignatus by the University of Washington
Alumni Association

1994 Inducted into American Academy of Achievement
Makes largest project to date for Tacoma's historic Union Station

1995 Begins "Chihuly Chandeliers Over Venice" project
Receives honorary doctorate from Pratt Institute, Brooklyn
"Chihuly Baskets" tours US
Installs "Chihuly e Spoleto" in Italy
Temporarily installs 26 sculptural pieces in the village of Nuutajärvi, Finland

PHOTOGRAPHY

Special thanks to Terry Rishel who photographed the majority of the *Seaforms* in this book.
Thanks also to the other photographers who contributed:

Roger Bransteitter

Dick Busher

Eduardo Calderon

Ira Garber

Claire Garoutte

Russell Johnson

Roger Schreiber

Mike Seidl

Rob Whitworth

Without the extraordinary talent and insight of the photographers
who have collaborated with me over the years, the publication of my work
would not be possible. And, although my work is exhibited widely,
it is through books that most people are able to see and appreciate it.

CHIHULY SEAFORMS

Special thanks to those
who worked on this book:

Karen Chambers
Diana Johnson
Megan Kitagawa
Rob Millis
Heidi Myer
Barry Rosen
Dianne Simmonds
Jack Woody

Portland Press, P.O. Box 45010
Seattle, Washington 98145-0010 USA
☎ 800-574-7272
www.portlandpress.net

I would like to thank
all of the Gaffers & Glassblowers
& all the artists & artisans that
have made my glass possible.
And thanks to all the rest of you
that have given so generously
of your time & talent. You're
bringing happiness & joy
to people all over the world.
especially me —. Thank you —
Chihuly
Dublin
7·1·95

for
Leslie